TURNING PRO

♦ ♦ ♦ ♦ ♦ ♦

TURNING PRO

♦ ♦ ♦ ♦ ♦ ♦

A Guide to Sex Work
for the Ambitious
and the Intrigued

♦ ♦ ♦ ♦ ♦ ♦

by Magdalene Meretrix

greenery press

Published in the United States by Greenery Press, 1447 Park Ave., Emeryville, CA 94608.

www.greenerypress.com

ISBN 1-890159-30-1

Readers should be aware that the activities described in this book carry some inherent risk of physical injury and/or emotional distress. While we believe that following the guidelines set forth in this book will minimize these potentials, the writer and publisher encourage you to be aware that you are taking some risk when you decide to engage in these activities, and to accept personal responsibility for that risk.

In addition, laws governing sex work vary from state to state. You are responsible for researching sex work laws in your location and acting in accordance with all laws.

In acting on the information in this book, you agree to accept that information as is and with all flaws. Neither the author, the publisher, nor anyone else associated with the creation or sale of this book is responsible for any damage sustained.

CONTENTS

FOREWORD

BY CAROL QUEEN, ED.D.

T he publication of this book is a radical act. Whores and exotic dancers, bar boys and porn performers, all of us are supposed to fall into sex work like we're falling off a cliff, because the circumstances of our lives send us tumbling down a slippery slope and we can't stop ourselves. We certainly aren't supposed to choose to do it because we think we'd be good at or enjoy it. "Turning Pro" represents a new level of legitimacy for sex workers – up until now we could pen apologia or memoirs, and more recently analyze the politics and power relations of our experience, but not invite others to join us in the sex trade. We certainly couldn't inform our new colleagues how to do it right. The vast knowledge base of sex workers has largely existed in the twilight, inaccessible even to many of us.

This vast body of information is hinted at in Magdalene Meretrix's work. Although her perspective is broad and her experience deep and useful to others, there's much more to be said about this heretofore nearly invisible topic. But "Turning Pro" bursts the floodgates: After this book, more information will follow. Like a client's limp dick, once the word gets out, it's pretty difficult to stuff it back in (though as any pro knows, it *can* be done, and we must all be vigilant to make sure our voices don't

get even more suppressed than they already are). More and more women, men, and transfolks will come to sex work in the future already armed with the information that we usually get on our backs, in front of an audience, or, if we're really lucky, from an older, wiser whore. "Turning Pro" is full of the kind of helpful hints I wish I'd had access to when I hesitantly dipped my toe into the world of prostitution. Thanks to the experienced women around me, I found the water was fine, but too many sex workers have a very different experience. I once met a woman at an anti-prostitution conference who had been a working girl for years, getting her clients through an agency and never once meeting another whore! No wonder her view of the world was one-sided. Especially in the face of social stigma (and legal pressure) against us, we need to talk to one another, share information and support.

One reason no book like this has been written before is that it's been presumed it would be illegal to teach people how to do an illegal act – prostitution, that is. Of course, as Magdalene reminds us, most forms of sex work *are* legal. I'm going to play it coy on this matter – I'm not going to tell you to do illegal sex work any more than Magdalene does, but if you do, there are some things to keep in mind besides the way a cop is likely to treat you. In doing prostitution you're up against state control of sexuality and, if you're a woman, women's economic opportunity. Those aren't small-scale issues – no wonder we're caught between changing sexual mores and inflexible legal structures. Nowhere are the interests of the state so bald than in the persecutions of prostitutes and their customers: No one is supposed to be able to get, or profit from, sexual pleasure outside of state-sanctioned relationships. The same folks who are fighting pornography, gay marriage and sex toy sales are the people who don't think any of us deserve an orgasm obtained as easily as we could call for take-

out. At issue is nothing less than the role of sexual pleasure, who should have it, and how we're allowed to get or provide it.

In a perfect world everyone would enjoy the work they do. Clearly many people don't occupy such a utopia, including many sex workers. The big secret, actually, is how many sex workers *do* enjoy their jobs. Not everyone is cut out for the sex industry, and not every sex worker will be equally happy in every form of the work. It takes a special kind of person to work with customers' sexuality without feeling used, burned out, dissociated from their own eroticism. And just as different skills sets are required for accountants, auto mechanics, and teachers, sex industry jobs have specific requirements of their own.

One of these job requirements is something we can't expect the culture to instill in us, and if we want to have a good life as a sex worker we have to make sure it gets instilled some other way. I'm talking about respect for sex. Sure, sex sells whether or not you respect it, though perhaps not as well. (It may even sell whether or not you're any good at it – that's how hungry people are for sexual touch and erotic entertainment.) Make no mistake, we *are* in it for the money. But as many a sex worker has learned, you risk selling something of yourself when you don't like sex but decide to do sex work anyway, just to make a buck.

Speaking of what we sell, let's get one thing clear: Even if you're selling your soul, you are *not* selling your body. At most, you're renting it out – charging for your time like everyone else does. What kind of culture tells prostitutes they're selling themselves, but doesn't say the same to pro football players under contract?

Respecting sex means respecting yourself for working with sex. The greatest internal challenge most sex workers face, especially those who work directly with customers, is respecting the customers' desire as well as their own preferences, boundaries, and sense of dignity. How can you respect yourself when you dis-

respect what you're doing and the people you're doing it with? One of the most pernicious social myths about sex workers says we must fundamentally hate what we're doing and hate ourselves for doing it – if that were true, we'd really be the fucked-up and abused waste particles the culture so frequently makes us out to be.

And I'd be dishonest if I pretended none of us struggle with this awful contradiction. Those of us who are sex-positive, who respect our position as providers of sexual entertainment and service, and who had a choice in what we do largely fly under the radar – the "sex worker as victim" myth ensures that we are not often recognized or acknowledged. No one really knows how many of us live our lives this way – but the number is higher than the shrinks or the sociologists, Geraldo or Ricki Lake will ever say. It would be such a service to today's sex workers, operating under the burden of these negative assumptions, and to the sex workers of tomorrow, if we could just get society to understand what so many of us know. You can live a good life as a sex worker, have plenty of self-respect and set your own preferences and boundaries – especially if you have support and knowledge. And that's where Magdalene starts: empowering sex workers to take themselves and their jobs seriously.

Perhaps you picked up this book because you occupy a particular position in the sex industry, or are thinking about sex work as a career or a quick stopgap measure to cover for being unemployed or to meet specific financial needs. Perhaps you're interested in making porn or stripping but not prostitution, would rather wear sweat pants and talk hot on a phone sex line than set foot in a Nevada brothel. It's true that there are great differences between hands-on and hands-off sex work, between work that is primarily visual and that which is aural, and that you may have no interest in crossing any of these lines. But please read Magdalene's whole book anyway, even the chapters detailing

things about sex work you don't think you need to know. The sex industry is diverse, but certain elements and insights hold true across various styles of work. Information is power – and flexibility. Contrary to the notion that sex workers have no choice, Magdalene reminds you that you have many, many choices.

So you want to be a sex worker? Live well and prosper, by your example making more space in this society for pleasure, for sexual play and comfort, and for other sex workers to live safely and with self-respect. Take your limits seriously, get some support, and treat yourself like a professional. The stigma against us partly stems from ignorance, so dispel it when you can. We don't live in Utopia, but on good days a sex worker can glimpse a society in which sexuality, pleasure, and erotic variation are valued, not degraded. Remember, we're the pros. Let's use our siren song, beckon society in the right direction.

C.Q.

San Francisco

Valentine's Day, 2001

Introduction

S ex worker. Does that phrase sound strange to you? You prob-
ably won't find it in your dictionary, but the phrase is growing
more and more commonly known.

A sex worker is a person whose work involves sex – specifi-
cally, someone who works in the sex industry. While a sex therapist
probably wouldn't be considered a sex worker, a sex surrogate
might, and strippers and prostitutes definitely qualify.

It sounds like a euphemism, doesn't it? In a world where gar-
bage collectors are "sanitation engineers" and homemakers are
"domestic facilitators," it's easy to assume that "sex worker" must
be a politically correct euphemism for prostitute. But sex worker
is not just another unnecessary synonym. After all, the world of
sex is a vast one, and there are a lot of different ways to make
your living doing it, from photographic modeling to being a pro-
fessional submissive. "Sex worker" is a powerful phrase – it's
accurate, descriptive, and more concise than saying "person work-
ing somewhere in the sex industry."

If the phrase "sex worker" were just a euphemism, I'd have
little use for it. Personally, I love the word whore. It feels solid
and good in my mouth. Holy. Heal. Whole. Whore. Whore
sounds like a long moan of delight, trailing up from my cunt to
wrap around the world.

The Indo-European word root "ka" gave birth to many chil-
dren besides my beloved word, whore: words like "charity," and

"cherish." To me, being a whore is all about living full of love and ready to share it around. I am an affectionate woman and I love to have sex with many different people. It is no surprise that I decided to become a whore.

I choose to call myself a sex worker more often than a whore, though, because I've had so many other jobs in the field. I've worked as a photographic model, a dancer behind glass in "peep shows," a dancer on stage in strip bars, a phone sex girl, and an actress with one tiny role in a porn movie. I've worked with fetish sexuality as a dominatrix and as a professional submissive. I've worked as a prostitute: picking up a few clients on the street, working for an escort agency, working as an independent and in a legal brothel in Nevada. Now I work as a sex writer, sharing my sex work experiences with others. I've been a sex worker for 17 years. It is my passion, my heart, my calling and my career.

I sort of tumbled into sex work in my late teens while hitch-hiking around the country. People who stopped to give me rides would offer to trade money for sex and, once I ran out of money, I started accepting. Looking back, I wish I'd had a mentor or a textbook. I made so many mistakes and learned so many lessons the hard way. It's not surprising that very little advice is available for prostitutes – who wants to risk their freedom by sharing advice on an illegal topic? But not all sex work is illegal, yet advice for legal sex workers is just as scarce. Sex work isn't for everyone, but those of us who are well suited for the work shouldn't have to learn about our careers in a haphazard, hit-and-miss fashion.

That's why I decided to write this book. It seems that every time I tell someone that I am a sex worker, they shower me with questions. Even people who are not interested in doing sex work are still filled with a thirst to know what a sex worker's life and job are like. The need to know is even stronger in those who think they might enjoy a career in sex work. The information is

precious and valuable and there are more people with questions than I could ever answer in person.

"How can I get a job as a submissive?" "Doesn't it frighten you to go to strangers' houses?" "Have you ever been arrested?" "How much money does a stripper make?" "Does your mother know what you do for a living?" The questions go on and on. This book is my chance to answer questions from people I may never meet.

Sex work has changed my life and my perceptions – sometimes painfully but most often not. I would never advise that someone go into sex work. It's not an easy career and it's definitely not for everyone. But there will always be people, like me, who gravitate towards the work. For those who never go into sex work, I hope this book will give them a true feeling of what it can be like. For those who do, I hope that I can be the sort of mentor I always wished I'd had.

I realize that this book is written mainly about female workers in the United States and I apologize to those in other countries or other situations. I have only worked in the United States so I just don't know from personal experience what it's like in other places. I am female so I can't very well tell you what sex work is like for a man unless I describe someone else's experiences. But I can tell you what I know and I can be very honest and open about my experiences and observations.

If you men were hoping I'd tell you how to become an escort, perhaps you should be reading my dear friend and colleague's book instead:

The Male Escort's Handbook: Your Guide to Getting Rich the Hard Way, by Aaron Lawrence, Late Night Press, October, 2000.

Some of the things that I have done are illegal. I'm not afraid to write about them, though, because I no longer engage in illegal sex work. I have been arrested and convicted. It was not fun,

but it was a learning experience... and now you can learn from it without having to experience it for yourself.

I don't want anyone to break the law. In this book I will sometimes talk about illegal prostitution. That doesn't mean that I am advising other people to do it – please don't! I once spoke with a sex worker who had never been arrested. She said that she almost wished she had been because it would have been like "paying her dues" and it would have made her experience complete. I don't think she believed me when I told her that her experiences as a sex worker were already complete and that missing out on being arrested was no great loss. I hope that you will believe me, though.

Oh, and that one question, "Does your mother know what you do for a living?" Yes, she does. I told her about it fifteen years ago, when I was eighteen. My mother does not understand what I do or why I do it (though she might, if she reads this book!) but she has been as supportive and understanding as I could ever have hoped.

"There is only one thing that I have ever wanted for my children," my mother told me when I "came out" to her about my sex work, "and that is for them to be happy. As long as you're happy with what you're doing, I support you 100%." So this book is not only dedicated to all my colleagues in sex work, and to my patient and understanding lover who stood by me throughout the writing of this book, but also to the woman who gave me life and raised me to think for myself.

And yes, Mom. I am happy. Very happy indeed.

Is Sex Work Right for You?

No one but you will be able to honestly determine whether sex work is right for you or not. Before you make any other decision about sex work, you should take a moment to consider whether you are suited for sex work. The time to carry out your

"searching and fearless moral inventory" is before you begin working, not during the depths of sex work burn-out.

The first thing to consider is your overall attitude towards sexual expression. If you sincerely don't like sex, this is the wrong line of work for you. Even those areas of sex work that don't involve sexual contact will bring up issues related to sexuality. If you harbor inhibitions or feelings of guilt surrounding your sexuality, you may want to consider whether these will pose insurmountable obstacles. It could be that you will find sex work liberating. It could also be that you find yourself imprisoned within your own attitudes. Which will it be? Consider this question thoroughly before deciding to embark on a career centered around sexuality.

If you feel that sex work can be a positive learning experience for you rather than a psychological burden, the next thing to consider is what level of contact with clients you can handle. Sex work is a wide field and contains work with a minimum of contact, such as phone sex, as well as work with a maximum of contact, such as prostitution. What level is right for you?

There are a variety of ways to think about this issue. If you favor thought experiments, go to a crowded place and look at people. Imagine having sex with every person you see, no matter how physically unappealing you find them. Concentrate on people who do not match your preferences. You may find that just thinking about having sex with a man who is overweight or underweight or eighty years old or has hairs growing out of his ears is too repulsive for you to deal with. Or you may find that these things don't matter to you as much as you thought they would.

If you prefer to experiment in the real world, go to a singles bar and pick someone up. Don't look for a cute guy. Look for someone who seems safe and sober but is not the type you would normally choose. The best way to pick someone is to make eye

contact with single men and smile. When someone smiles back, go talk to him. If he starts dropping hints about sexual interest, bluntly tell him that you'd like to get laid tonight but you aren't looking for a relationship. Make sure he knows that you expect to be treated with respect and that you insist on safer sex. Then go to a hotel room and have sex with him. The experience should give you a good idea of how you feel about no-strings sex with strangers. Pay close attention to how you feel about yourself afterwards. Do you feel demeaned even if you were treated well? Or do you feel like you could easily do the same thing for money? You may be surprised at the things you learn about yourself after this experiment.

The decision is entirely yours. If you have doubts, don't rush into anything you may regret later. But if you think long and hard and still find yourself eager and impatient to try sex work, don't hold back. You may discover a fantastic career that satisfies you in many ways.

Let's start our exploration by looking at some of the different careers available in the field of sex work in the next chapters. Afterwards, we can deal with some of the specific issues.

STREETWALKING

T hanks to Hollywood, when most people hear the word "prostitute," they think of streetwalkers. The National Task Force on Prostitution has estimated that only five to 20 percent of U.S. prostitutes work on the streets, though. They estimate that one million American women (1% of the U.S. female population) have worked as prostitutes at some point in their lives, which would work out to 50,000 to 200,000 U.S. women who have hooked on the streets.

Most prostitutes choose a different means of contacting clients because street work is the most dangerous form of sex work there is. There are some women who enjoy street work, though. The ones I've spoken to who claim to prefer it, when asked why they like streetwalking, most often mention the freedom. I picked up my first few clients on the street, both in town and while hitchhiking around the country, but I quit hustling the streets as soon as I found out about other venues. I was really glad to get off the streets – it seems to work for some women, but I was too nervous to continue street work.

I talked with a beat cop in a major U.S. city about streetwalkers. He's been working the streets for five years and in that time he's seen over a thousand different women walking the streets. I asked him how he can tell the difference between a woman out for a walk and a street prostitute and he said that he'd know street hookers because he'd see them, "approaching cars,

approaching multiple males in certain known areas," and recognize them by, "the way many dress, the way many walk to attract attention."

Walking is a key factor – after all, it's not called Street Standing. Although Hollywood often depicts the hooker standing on the corner (and although real-life hookers do sometimes stand in one place), the wisest choice is to keep moving. Not only will a streetwalker be arrested for soliciting customers, she can also be arrested for loitering.

More and more cities are cracking down on streetwalkers. Times Square in New York City used to be a carnival of flesh and now it's Disney Central. Seattle has their S.O.A.P. (Stay Out of the Area, Prostitutes) program where single women who are deemed "suspicious looking" can be arrested for walking down the sidewalk alone in the wrong neighborhood at the wrong time of the day. In many cities, the police will confiscate a man's car when he is arrested on suspicion of patronizing a prostitute.

Many prostitutes claim that the laws were not strongly enforced until the AIDS crisis. Prostitutes became a handy scapegoat, despite evidence that we are not vectors of HIV infection. The U.S. Department of Health regularly reports that prostitutes account for 3% to 5% of the STD cases, compared to teenagers who account for 30% to 35%. Unfortunately, statistics rarely stand up well against public sentiment.

One law in particular that pops up here and there is designed to stop streetwalking but instead ends up encouraging unsafe sexual practices. The charge is "common streetwalking" and the only thing a woman has to do to be found guilty is to be found in possession of condoms. Common prostitution isn't actually a prostitution charge because no sex occurs and no money changes hands. But it's treated the same way as a prostitution arrest and the stigma attached to common prostitution is just as fierce. Massachusetts is one of the states with laws against common pros-

titution – 1997 Boston arrest records show 23 prostitution arrests, five of which were for common prostitution. Thirteen of those arrests were for solicitation (offering money for sex) and occurred in one night at one location. This is typical of street prostitution arrests in most cities – every now and then the police spend the night out on the town but most of the time it's business as usual. Those 23 arrests, by the way, were almost twice as many as the year before. The arrests do keep going up in number so, despite lax attitudes towards streetwalking, it's never a good time for a streetwalker to grow overconfident!

It's a sad reality of streetwalking that the cops are one of the obstacles. While some cops have very bad attitudes towards streetwalkers, most cops do realize that the hookers they see everyday are human beings. Streetwalkers who avoid arrest have usually gotten to know the local police patterns. They know when the shifts change and they take a half-hour break then to avoid the fresh cops when they first hit the streets. They watch which areas of town the police are currently focusing on and avoid them. They have learned to recognize most cops on sight and they notice how often the cops notice them.

Part of the danger of street work lies in the standard "pickup" method. Neither I nor my potential client felt comfortable talking about business while I was standing on the street with my head stuck in his car window. He'd ask, "need a ride?" and I'd hop in his car. Getting in a strange man's car is one of the more dangerous things a girl can do, especially in a questionable neighborhood, late at night. These days I read the stories in the news: women dismembered and left in dumpsters, strangled by a heavy man stepping on her neck, locked to a signpost and set on fire, even killed by being anally impaled on a truck's stick shift. I read and think, "there, but for the grace of God, went I."

Don't get me wrong: other forms of sex work are not risk-free. A New York dominatrix was shot and killed in her upscale

Manhattan apartment. Strippers and porn stars periodically get stalked. A lingerie model I knew in Chicago went on a date with a man she thought didn't know her but who turned out to have an obsessively large collection of her photos pinned up on the walls of his apartment. I had to bite a client in a Nevada brothel to make him stop strangling me. There are risks in any line of sex work.

I turned tricks on the streets and with truck drivers any number of times and the worst thing that ever happened to me was that a trucker who didn't want to pay put me out of his truck in the middle of nowhere. It took me all of 45 minutes to get another ride. But I was lucky with street work and I didn't stay on the street very long before I found a safer place to work. Far too many women are not so lucky.

It's not a good idea to be too flashy when looking for customers. A good streetwalker will be dressed in a way that's sexy but not too revealing. A client in Chicago told me that he saw a streetworker wearing nothing but a g-string one cold winter day. That's not a very wise way to work – though my client told me she wasn't on the sidewalk for very long at all before a car picked her up!

With all the legal crackdowns, most of the Hollywood stereotypes such as waving, winking or walking around saying "want a date?" are just not safe anymore. It's much safer for a street worker to either stick out her thumb as if she were hitchhiking or just make prolonged eye contact with any slower-moving driver who doesn't appear to be a cop. Hanging around near a phone booth isn't a bad idea because a woman with a phone in her hand, talking or appearing to talk into it, is not loitering. If she's not using the phone, she can always claim she was waiting for someone to call her back.

The best way to figure out which streets to work is to look at where other people are working. Be careful, though. I used to

walk home from the strip bar where I worked every night and there were a few times when streetwalkers thought that I was streetwalking and chased me threateningly, yelling at me to get out of their area. Like many things in life, use discretion and keep your eyes open.

Sometimes a driver will pull up to a street worker to ask her if she needs a lift, but if he's skittish about getting arrested in a sting, he's just as likely to pull up ahead of her and wait for her to approach him. She carefully assesses his body language at that point in order to decide if he's looking for a date or not and, if he gives good signs of it, like lots of eye contact himself, she'll often just climb into his car without saying much at all.

A lot of guys will want to see or touch your breasts or vagina before talking about money. There is a widespread belief that a police officer will not undress or do anything sexual before an arrest. The truth is that if a police officer really wants to arrest you, he'll find something to arrest you for, no matter what you do. It's up to you whether you give guys a free peek or not, but most will trust you more so it's usually worth doing. My response was usually, "I'll show you mine if you show me yours." They still may be a cop, even if they show you their penis, but at least you tried your best and maybe a lawyer can help you at that point.

There's only a split-second to decide whether to get into a car with someone. In just a brief moment, a street worker has to assess his cleanliness, the look on his face, his attitude and more. Is he a cop? Is he a homicidal maniac? The frightening truth is that most cops and most homicidal maniacs look just like everyone else. Psychologists who work in correctional facilities say that mass murderers are frequently the most charming people they've ever met in their lives.

This is one reason most sex workers prefer regular customers. There's no guarantee that a regular won't turn on you at some point, but if he's been decent before, the odds are in your favor

that he'll be decent again. The regular client is a known quantity. The easiest way to get regular clients is to give your phone number or a pager number to quality clients after you've seen them once or twice. The more regulars you have, the less time you'll have to spend out on the streets cruising for new clients. That cuts the risk factor down considerably. Not only that, but my regular clients have done some of the nicest things for me. There's a difference between a client and a friend for most people, but sometimes, when you're in a real bind, a regular client can be more of a friend than the people you thought were your friends.

It's best to avoid having sex in someone's car – that's a quick way to get arrested even if your client isn't a cop himself. If you're familiar with the area, you'll probably know some good motels, but don't be surprised if a client doesn't want to go to a place that you suggest. Many men who pick up streetwalkers are nervous about arrest or mugging and aren't likely to trust you much more than you trust them. It's usually better to just let the client choose a motel. Make him pay for it, too. Don't discuss money before you get to the room. Most guys won't pay you until you're in a room anyway.

Streetwalking doesn't pay as well by the hour as many other forms of sex work, but if a girl is in a good location and looks good (but not too good, lest potential clients pass her up for fear that she is a police officer or a transsexual), she can get plenty of business. Prices vary from region to region, but the average price these days seems to be around $20-$50 for oral sex and $50-$100 for intercourse. For those who charge by the hour, the going rates average around $60-$200 for an hour.

There's another sort of streetwalking that some women prefer. Instead of walking streets, you can walk rows of parked tractor-trailers. In trucker vernacular, a woman who streetwalks at truck stops is a "lot lizard." It may not be the most attractive nickname, but truckers' nicknames rarely are. I once worked with

a woman who talked about streetwalking at truck stops. I said, "oh, a lot lizard!" and she visibly shuddered.

"I hated to be called that!" she vehemently declared.

"Would you rather they had called you whore?" I replied. That shut her up.

Now, as you know, I have no problem with the word whore. I think it's a lovely word. For that matter, I think lot lizard is descriptive and cute, though I realize that my opinion may not be the norm. The truth is, no matter what you do and where you do it, someone will have a name for you and your work that just doesn't sit right with you. Will you cringe whenever you hear it, or will you accept it and move on?

Just as many lesbians have reclaimed the word "dyke" and many black people have reclaimed the word "nigger," we can reclaim the word "whore" for our own empowerment. As Norma Jean Almodovar wrote in her poem, "The Whore Word," "And what if I tell you / I don't care anyone if you call me a whore ... / What will you call me now?" What will they call you? And do you care?

There are various ways for a "Horizontal Highway Hostess" to attract business at truck stops. One of the most common methods – and by far the safest – is to talk to truckers on a CB radio. You have to be careful what you say, because the police listen in. It's not a good idea to discuss specifics over the radio (though lots of women do it!). A much better technique is to let people know you're there and patiently let things develop. Above all, try to avoid calling for dates on trucker's radios – it tends to annoy them and it's never a good idea to annoy people unnecessarily when you're trying to do anything underground.

Another method some women use is to walk around among the trucks or even to knock on truck doors to ask if anyone "needs company." I've talked to plenty of truckers and most of them say that knocking on their door is even more annoying than trying to use their radio. The money isn't always great at a truck stop –

from what I can tell, the prices haven't really gone up since I was working with truckers in the late Eighties — but if you're good looking you'll have some negotiating room. Don't forget that the truckers are making very good money – in many cases they have incomes commensurate with doctors and lawyers. But at the same time, most truckers are used to getting off cheap. The prices are around $30-$50 for a "half and half" (oral sex and vaginal sex).

The best hours to look for clients at a truck stop are between seven at night and two to five in the morning. Pull up in or near a truck stop with a CB radio in your car and just start chatting with the truckers. You'll want to brush up on trucker slang if you're not used to it or if you think you know it from the Seventies "Convoy" craze. A perfect example: in the Seventies it was okay to call everyone "good buddy" but now that phrase is only used to refer to homosexuals. CB radios have multiple channels. Some of the channels are typically reserved for specific things, such as the Emergency Channel, while others are open territory. Once you've found a channel or two you're comfortable with, try to stick with them so that regulars driving through the area will know where to listen for you. Pick a cute handle (some handles I've heard include "Sunshine," "Sugar Britches," "Li'l Bit" and "Sugar Baby") and start chatting away. Keep it clean but suggestive. "Looking for company? Commercial company? I'm looking for some commercial love here, come back."

Some women move around from exit to exit in one specific area as they work. This is partly to get a chance to connect with all the truckers who have stopped in the area for the night and partly to present a "moving target" in an attempt to minimize the chance for arrest. One bonus to working truck lots is that most truckers have enough space in their rig to "party" right there – no hotel rooms necessary. As far as I know, the police don't rent tractor-trailers to try to entrap lot lizards, so transactions are usu-

ally a little more relaxed since clients and workers are less nervous about the possibility that one another might be police officers.

A truck stop isn't a hazard-free place to transact business, though. There may not be as many cops around, but most truck stops have their own security guards. Before you think, "oh, just a Mall rent-a-cop," you should know that these security guards have the authority to detain you and they also have the freedom to do far worse things to you than the average cop does.

Some security guards will be decent to lot lizards and turn a blind eye towards what goes on in the lot, while others will be dead set against your presence there. As with any situation, keep your eyes and ears open at all times and learn your terrain.

Don't assume that truckers are all automatically safe, either. If you're tempted to think of hooking at truck stops as one of the safest forms of sex work, think of Robert Ben Rhodes, mild-mannered truck driver, who was arrested in 1990 after fifteen years of torturing and killing women as he drove his shipping routes. Detective Rick Barnhart, one of the officers who questioned Rhodes when he was arrested, commented on how smooth-talking and at ease Rhodes was, even under pressure. "Does he look evil to you?" Barnhart asked. "Not at all. That's how he got away with it."

Homicidal maniacs look like normal people. Be careful.

For More Info

Truck Driving Slang As It Is Slung
http://www-vis.lbl.gov/~slau/trucks/slang.html
A few current phrases to help you translate just what those big-rig drivers are talking about.

16

♦ ♦ ♦ ♦ ♦ ♦

streetwalking

Live Girl Shows

In my earliest days of legal sex work, I worked in the live girl show. There are various ways that girl shows are run, so I'll start by describing what it was like where I worked and then discuss some of the variations you might find.

The live girl show booths where I worked were special booths in adult bookstores. The bookstore might also have a private movie viewing booth and general movie booths in addition to the girl show. On the store side, the booth has a locking door, a stool, sometimes a telephone, a coin slot, a tip slot and a window that is either covered or made of two-way glass. On the girl side, there is a lounge for the workers and booths that pretty much mirror the client's booths, except the worker's side is usually carpeted and the chairs are more comfortable. In some bookstores, there is no lounge area and the worker has to either hang out in her booth or sit behind the counter with the store clerk while she waits for clients.

When a client wants to spend time in the live girl booth, he buys tokens at the front desk or gets change (some machines work with one-dollar coins). If the girl of his choice doesn't already know he's there, he rings a doorbell in her booth to get her attention. Then he drops tokens into the coin box, which sets off machinery that turns on a light and lifts the window covering if there is one.

Having made visual contact, I'd guide my customer – or customers if the cardboard lifted to reveal a couple – in "sliding something nice through my tip hole" (giving me some money) and "making himself comfortable" (unfastening his pants and masturbating). I wasn't allowed to tell my customer how much money to give me. According to city law, agreeing to exchange money for a sexual act was prostitution, thus illegal. So sometimes the tipping process was a comedy of errors, with my client trying to get a bargain and me trying to make a living and each of us wondering if the other were a cop.

If we finally settled on an agreeable amount, I'd strip for him, spread my legs and put on a good show of masturbating myself. Some men asked for something special – specific words, specific moves, fetish shows where I smoked a cigarette or peed into a cup for them – but most men just wanted to watch me play with my body while they masturbated.

My peep-show days were spent in a medium-sized city, so the establishments were small compared to places like San Francisco or Seattle. Often I'd be the only worker on shift where I worked, but establishments in larger cities often have a dozen or more workers per shift. It's more common in larger cities to see businesses that are just live girl shows, not part of a bookstore or strip bar. More and more cities are offering girl shows that are broadcast over the Internet via live webcams. At least one strip bar that I know of has opened a live girl show in a drive-through window.

Prices vary from area to area, but you can expect to get somewhere between $5 and $50 for a show. Five dollars doesn't sound like much but most clients don't get much for five dollars, either. For example, a minimum show might only involve naughty talk and gestures from a fully dressed worker. The more layers of clothes, props and sexy ideas you have, the more money you'll be able to make in a live show. Of course powers of sexual persuasion come in very handy as well.

In the larger girl shows where you're dancing for several clients at once, you'll need to learn to play to different windows. With multiple viewers, the show goes on and on so there's no way to estimate earnings per show. Dancing for multiple viewers is more like dancing in a strip bar in that you play up to whomever is tipping you.

One colleague complained to me after her first night working a multiple viewer girl show. "I was in tears by the end of the night," she told me. "I'd start giving a show to one guy and then another one would come in and start getting a free show. I hung my robe over one leg to block his view and told him he'd have to wait until the first guy was done but he just kept dropping tokens!" This is a perfect example of what happens if you aren't able to be flexible in your sex work.

So many aspects of sex work are related or have cross-over elements, and girl shows are a perfect example. Girl shows involve some of the element of club dancing, some of the elements of porn acting and some of the elements of phone sex. A truly skilled girl show worker is a very versatile sex worker indeed!

And what about that money you're gathering up from your visitors? Do you get to keep all of it or will you have to split it in half like in a strip club? That depends on where you end up working. In some places, usually in smaller towns, the management keeps all the token sales and you keep all your tips. In the west coast girl shows that have unionized, you punch a time clock and get a nominal hourly wage similar to a waitress wage. Some of the multiple-viewer peep shows don't have tip slots at all – the workers split the token proceeds with each other and management. In places where there are tip slots, the same goes: you'll usually have to divide your tip money among the other girls on shift and with the management. The actual split depends on where you go to work – as always, ask about your working terms before you commit yourself to a job.

The web live show workers tend to get paid a straight hourly wage. When I inquired with one such establishment in Chicago, I was told that the workers are paid $30 per hour and are allowed to work up to twenty hours per week. Of course these terms will vary depending on where you choose to work.

Another option for live girl shows is to become an independent web worker out of your own home. This option involves some overhead for equipment and advertising and a strong dedication to your work, but for more and more workers it's becoming a viable option. Home web broadcast, like phone sex, is also a great way to supplement a budding career in porn. As with any entrepreneurial venture, you'll want to check with your lawyer before setting up a home web broadcast system. Due to zoning laws, it may be illegal for you to work out of your home, even over the Internet.

While live girl shows, no matter how they're performed, don't involve physical contact between the worker and her client, there is one kind of sex you may find at the peeps – the girl-girl show. The girl-girl show is a lesbian performance, either real or fake, for tips. In some establishments, the girl-girl show is expected. If that's the case, you'll be informed when you're hired. In other places, the girl-girl show is illegal but sometimes the workers will do girl-girl shows anyway for customers they trust. If there's no law against girl-girl shows and your employer doesn't require it, the other workers will usually ask you ahead of time if you are okay with the idea. In that case, it's always up to you whether you do girl-girl shows or not.

When you're behind a pane of glass, it's pretty easy to fake a girl-girl show. One woman I worked with would always fake the shows by putting the back or side of her head towards the glass. The customer could see her hair moving and the overall visual of her arms on my thighs, her head between my legs and blissful expressions on my face but there was no way he could tell if her

tongue was actually making contact or not. It wasn't. She and I would take turns sticking our tongue partway out and pretending to lap at each other's crotches.

There are some places where you can't fake the girl-girl show, though. I know of at least one West coast peep show that offers a lesbian show in a booth like a restaurant booth. The customers sit in the seats and the women get on the table and use their tongues and dildos on each other right under the customers' noses. The customers aren't allowed to touch the workers but they can get their faces inches away from yours. There's just no way to fake a girl-girl show in this situation, so if you can't stand the thought of lesbian sex you just won't be happy working in that style. Of course, if you're a lesbian or bisexual exhibitionist, this could be the job for you!

For More Info

[Don't forget to check out the chapter on strip bars! As a peep show dancer you'll want many of the same resources.]

Sam's Web Cam Cookbook

http://www.teleport.com/~samc/bike/

A complete online book that explains the details behind running your own webcam. Excellent resource!

Yahoo Web Cam Directory

http://dir.yahoo.com/Business_and_Economy/Shopping_and_Services/Sex/Online_Clubs_and_Galleries/Web_Cams/

This is a collection of adult web cam links. Browse through them to see what other sex workers are doing before you plan your own webcam site.

The Mitchell Brothers O'Farrell Theatre

http://www.ofarrell.com/

This is one of the wildest peep show joints in the country. It's located in San Francisco and it's world famous. Check out their room tour to get an idea of just how bold a peep show can be.

Being a Pro at the Two Girl Show

http://www.blackstockings-seattle.com/twogirlshow.html

An article from the Blackstockings 'zine about girl-girl shows.

Strip Bars

I started stripping when Louisville changed the nudity/alcohol laws. I was 18 and had been working in the live girl shows. The strip bars all served alcohol so the dancers had to be at least 20 years old. Then the laws changed and it was illegal to serve alcohol in an establishment where nudity was displayed. Most of the clubs split in half and built a second door. They had alcohol and go-go dancing on one side and soft drinks and nudity on the other side with separate entrances. With the new situation, nude dancers were only required to be 18.

Since those days, Louisville has changed its nudity/alcohol laws several times but I've seen the split strip clubs in many other cities. It's a common response to the legal restrictions. You'll see more laws and restrictions surrounding adult dancing than you'd ever imagine! There are towns where dancers are required to wear identification tags with their legal name on their ankle. There are towns where dancers can be fined if any of their pubic hair shows around the edges of their g-string. There are towns where dancers can be arrested for prostitution if they get too close to customers, even if no physical contact took place. There are towns where a dancer can be fined if she touches herself anywhere on her own body – including non-sexual areas such as her hip or stomach. Check it out: if adult dancing is legal where you live, I'll bet there's at least one regulation that doesn't make much sense to you.

Not only are there many different laws about dancing, but there are a variety of styles as well. Your day-to-day life will be quite different depending on whether you work in a "neighborhood bar," a dance chain like Déjà Vu, or an upscale local club. There are also "circuit dancers" who tour the country, stopping in at strip bars along the way. Your work as an adult dancer can range from a whirlwind tour of glamorous bars to a hole-in-the-wall with holes in the walls. You might end up at a club that looks like the ones you see on television and in the movies, or you might end up in a dusty dressing room with mice in the walls and cigarette butts on the floors.

Here's the part you might not have guessed – some of those hole-in-the-wall juke joints are every bit as much a cash cow as their upscale glamorous sisters! For example, I worked for a while at a tiny little strip bar on Dixie Highway just south of Louisville. The bar wasn't much to look at and the dressing room was never swept unless one of us got disgusted and swept it ourselves. But we were the first strip bar the Army boys got to and one of only three that they could get to without blowing half their pay on cab fare to get into the city. You'd better believe we all knew when payday was!

Still, you should learn to use good judgment in choosing where to work. Every club has its own flavor and some of them have their own dangers as well. One colleague had to quit the business when her foot went through the floor of a poorly built and ill-maintained dance stage. She broke her foot and her ankle in more than one place. Workman's comp? Not if you're an independent contractor. Choose carefully where you work and always aim for the best.

I've worked in some clubs where the bar was between the stage and the customers so there was no way anyone could have touched the dancers. That was fun because I could focus on dancing. Sometimes I'd make eye contact with people sitting around the

bar and sometimes I'd go off into my own little world and just dance for myself. I've also worked in clubs where guys sat right around the stage and we'd get tips while dancing. I liked that because if there were a lot of guys in there I could get a good amount of money during a dance.

Some clubs offer "lap dances." What's that? Well, it depends partly on where you work. In some clubs, it means you sit on a customer's lap, both of you clothed, for a certain amount of time. You might wiggle on his lap or cuddle with him. In other clubs, you do the same but you're topless during it. The customer may or may not be allowed to touch your breasts, depending on how strict the club is and how much the local law enforcement lets the club get away with. The cost of a lap dance depends on where you work – I've seen everything from five dollars to $50.

There are also "private shows" in some clubs. Again, the definition of "private show" varies from club to club. In some clubs you sit in a booth together to drink champagne. Others can see you or there is a camera pointed at you. In some clubs it's the same but no one watches you. I worked in one club where a "private show" was a nude dance in a private booth while a bouncer stood discreetly nearby to make sure the client didn't touch the dancer. Does sex happen in private shows? Usually not. I have heard things and suspected things, but I don't know anything for sure. It's safest to assume that you are not expected to have sex in a strip bar – it's not one of the brightest places to turn tricks anyway. Like most things in sex work, private shows vary in price. I've seen anything from $15 to $300 for private shows.

A feature dancer deals with all these issues, but she usually deals with it in a different club each night. Feature dancers usually start out by making a porn movie and then they negotiate a tour deal with an agent. Circuit dancing can be a great way to supplement porn income and see the country at the same time. The dancing builds up publicity for your movies and your movies

make you more popular as a dancer. If you're interested in feature dancing, flip over to the porn and modeling chapter for more information about agents. One warning: the body standards for feature dancers are far more strict than for the average stripper. You'll need to be in tip-top shape and you may need to consider plastic surgery if feature dancing is your dream. Another potential drawback to circuit dancing is that the regular house dancers may resent your presence, but you'll only be there a night or two so it's pretty easy to ignore hard feelings and just go on with your work.

Speaking of night, not everyone works night hours. Many strip bars have a day shift as well. Some workers really like the day shift while others shun it like the plague. You'll be likely to hear either point of view from any dancer you ask. The day shift is generally slower-paced and more laid-back, but there is still plenty of money to be made in the daytime, especially if you get regular customers. If your club is located in a good district, you will see businessmen on their lunch breaks and also around 5:00 when they stop in for a while to avoid rush hour traffic. You may be thinking, "eight hours of working for two hours of customers?" But we sex workers have a motto when it comes to clients: "It only takes one good man to make your whole day!" Don't be too quick to assume that the day shift is the pits, but of course you shouldn't stick with it if it isn't working for you.

In most cities that allow exotic dancing, there are plenty of clubs to choose from. Most of them are always hiring, so just make a list of clubs and start going down your list. Walk in, look for someone official and tell them you want a job. If they don't hire you, thank them and move to the next club on your list. Some clubs will ask you to audition but it's usually nothing fancy. They just want to see if you have a decent set of clothes and if you can walk across the stage without falling on your face. Never even consider working at a club if you're told that you have to

perform some sexual favor for someone on the staff in order to work there. It just isn't worth the hassle, no matter how great they claim their club is. If that happens, just move on down the street.

What you do for your money will vary from club to club. In some clubs, especially if you're a featured dancer, you may get paid a straight salary to dance a certain number of songs per night. In some clubs the workers ask customers for jukebox money before or after they dance. Jukebox money either goes entirely to the club or the dancer gets to keep half of her jukebox money. In some clubs the customers can tip the workers while they're dancing. In other clubs, touching a dancer on stage is taboo.

In some clubs in larger cities, the workers are required to pay a fee each night to work. Sometimes these fees are quite high – $100 per night is not unheard of. This fee is offset by the high earnings a worker can expect. A dance fee ensures that the club always makes money and only keeps the top-earning workers around. It's hard on the dancers, but the club owners are the ones who set the rules. I know it sucks, but if you don't like the rules, don't dance in the club. Your other option is to get involved with the activist groups who work on unionizing clubs and getting better working conditions for the dancers.

The classic source of income for a dancer is selling drinks. In some places the law forbids hustling drinks. I worked in such a place and we sold "entertainment tickets." A customer paid for the ticket which entitled him to a certain amount of time with a dancer who would then get a complimentary drink. Individuals in the legal sex work industry get amazingly clever when it comes to circumventing laws! Drinks (or whatever your club calls them) usually start at between $7 and $20 and the dancer gets between 30% and 70% of the money. 50% is the standard split. Think carefully before accepting a lower percentage.

Drinks go up in cost until they start to merge with the "private show" I mentioned before. A bottle of champagne often comes with a trip to the "party room" or whatever you club calls its private area. Champagne tends to cost between $30 and $200 a bottle. Of course there are all sorts of tricks for getting through a bottle of champagne without getting drunk. Keep offering champagne to the customer. Pour yourself a glass and empty it in the ice bucket when he's not looking. Carry a glass with you to the bathroom and dump it out while you're in there. Offer champagne to your colleagues. Finally, when the bottle is nearing empty, you can turn it upside down in the ice bucket, spilling out what's left.

Be careful with these sorts of drinking games – if you're too obvious you'll anger your customer. But don't be afraid to play them, either. Getting drunk at work might be fun once or twice but it's not good for business. You'll make far more money sober. Oh yeah, those "entertainment ticket" drinks? Mine were always straight grapefruit juice. If you're with a guy who insists that you drink, you can get the bartender to put a splash of alcohol on top so that he can smell it.

You'll need to befriend your bartender ahead of time if you want to pull off sly tricks like that, though. Get to know your bartender and discuss your concerns with him or her. Chances are the bartender already has some trick phrases or gestures for you to use in certain cases. And don't forget to tip your bartender and servers at the end of the night. The service staff are your friends in a strip bar and they can really help you sell drinks, but only if they feel there's some incentive for them.

Once I make friends with a bartender, I barely have to work any more. I can just sit down and start talking to a customer and before I know it, the bartender is right there, asking him if he'd like to buy me a drink. I love this method of selling! It's so much nicer than asking for drinks – instead of looking like a barfly

lush, the customer, bartender and I have just entered a fantasy world that mirrors the world we see on TV and in the movies. "Would you like to buy the lady a drink?" It's a perfectly natural question.

The illusion is what you are selling, not the drink; the illusion of meeting a beautiful woman at a bar or of going out together on a date. The more you can maintain this illusion, the happier your customers will be. Happy customers will spend more money and come back to see you again. So the more incentive you offer those around you to sell your drinks, the more chance you have for quiet conversation instead of "buy me... buy me.. buy me."

Finally, what you wear will depend on where you work. If you have a chance to check out a club ahead of time, you'll see what the other dancers wear. Enlist one of your male friends and go out for a night on the town. Drop in on as many strip clubs as you can and stay long enough to get a feel for the atmosphere. You can even get away with taking a pocket notebook with you and making notes to help you remember your impressions of each place. Chances are, no one will notice your note-taking; if they do, you can just smile and tell them you're doing some home-work.

Once you've decided where you want to look for work, put together an outfit that you think will fit in with the club's atmo-sphere. Toss it in a gym bag and carry it along with you in case you get asked to audition or, even better, get a job offer on the spot. Swallow your shyness and go for it. Your audience awaits!

For More Info

Stripper Power: For Strippers, By Strippers
http://www.stripperpower.com/
A fabulous site run by adult entertainers for adult entertain-ers.

The Exotic Dancer Page:
http://www.exclusivetvlnet.com/dancer/index.html

A page for dancers that includes an excellent message board where exotic dancers can get together and discuss important issues.

Danzine
http://www.danzine.org/

A Portland, Oregon based 'zine for strippers.

Exotic Dancer's Alliance
http://www.bayswan.org/EDAindex.html

"Exotic Dancers Alliance is a collective group of self-identified female exotic dancers collaborating together to obtain adequate working conditions and civil rights within the sex industry."

Yahoo: Strip Club Directories
http://dir.yahoo.com/Business_and_Economy/Shopping_and_Services/Sex/Adult_Services/Exotic_Dancing/Strip_Clubs/Directories/

A collection of strip club databases and adult entertainment directories. This is a good place to see what clubs are in your area and read reviews to see where you might like to work.

ESCORTING

I'll never forget the day I found out what an escort is. I was working in the peep shows at the time and happened to be sitting behind the desk, talking to the clerk because I was having a slow day and I was bored. A couple came in – a slightly balding man in his fifties and a stylishly dressed blonde in her twenties. They selected a movie and rented the private showing booth to watch it together. When they were done, the man left immediately while the woman stayed to shop.

The clerk cleaned the movie booth and when he came back behind the counter, he told me that the man had left his watch. I asked if he intended to give it back and the clerk said that he would if the man came to ask for it.

"Well, there's his girlfriend. I'll give it to her," I said, scooping up the watch before the clerk had time to protest.

"Excuse me," I said to the blonde, "but your boyfriend left his watch in the booth."

The blonde just laughed. "He wasn't my boyfriend. He was a client."

"A what?"

"A client. I'm an escort."

"What's an escort?"

Her answer set loose a deluge of additional questions until she left, probably beating a hasty retreat from my overeager curi-

osity. Each answer she had given me made me even more excited to ask questions. She had just been paid to have sex? She had been paid hundreds of dollars?! She worked for an agency that found these men for her? She found the job in the phone book?!

I did my own phone book research that night when I went home and before the week was out I had my very own job as an escort – the highest-paying sex work I've ever done in my career. At the peak of my career, I made more money than my mother was currently making with a degree in psychology.

Escorting is usually, though not always, prostitution. There are escort agencies that just offer companionship and/or private nude modeling. I know because I used to work for a legal escort agency. The legal agencies are very rare but their existence is what keeps the rest of the escort agencies open. Because an escort or her agency is only offering time in exchange for money, the transaction is, at least on the surface, not illegal. While some areas have special laws, like the one in Salt Lake City that forbids an escort to be nude within the first 24 hours she is hired, in most areas it's perfectly legal to charge money to spend time with someone. Think of the traditional "lady's companion" job that is partly domestic service, partly home nursing and partly just keeping an old lady from getting lonely. This is the model that keeps escorting quasi-acceptable.

But beneath that cautious legal exterior lies the heart of most escorting – sex for hire. The escorts know it, the clients know it, the agencies know it… and you'd better believe that the cops know it! Cops in most cities prefer to bust streetwalkers and their clients, generally turning a blind eye to call girls. Streetwalkers are easier to arrest and there's a general feel-good quality to "cleaning up the streets." But working as an escort does not grant you legal immunity. You're still a candidate for arrest and, as you can see in my chapter on getting busted, cops do arrest escorts. You'll see a lot of tips on avoiding arrest in that chapter. Those are tips

gained through personal experience. Here's hoping that none of you ever have to experience the humiliation of arrest.

While some workers start right in with independent escorting, it's not a bad idea to start with an agency if possible. Starting out working for someone else gives you a chance to learn from others who have been in the business for a while. It gives you a chance to see how other people run their business before you jump right in with owning your own business. It gives you an opportunity to see what clients in the area are paying for services and to know what parts of town the agency considers safe or unsafe places to send a worker.

The down side of working for an agency includes having to hand over a percentage of your fees. Any good agency is worth those fees because of their work in advertising, screening clients and keeping track of your whereabouts. A bad agency isn't worth working for at all. A bad agency will tell clients that you'll have sex with them. A bad agency won't always know where you are or if you're safe. A bad agency will get you busted, injured or worse.

The best way to know if you're about to start working for a bad agency is to know what to expect from a good agency. Let's look at the hiring process of an escort agency and then what you can expect from an average workday.

The first thing you need to do is find an agency to work for. There are plenty of agencies advertising in adult newspapers but the classic place to find an escort agency is in the phone book. Look under "escorts." If you live in a city with a population above one million, there should be several pages of escort agency listings. As you'll find out when you start calling them, there aren't really that many agencies. It's common practice for an agency to list itself under several different names. I once worked for an agency that had eight different listings in the phone book! Also, some of those agencies will have gone out of business since the phone book was printed.

If you look through the adult newspapers, try to find older copies of the paper to see if the agency has been around for a while. It's usually better to let an agency "season" before you look for work with them. That's one benefit of using the phone book to find an agency – it takes so long for the phone book to get printed that you know an agency listed there has been around for at least a little while.

Start by making a list of agencies to call. List only the agencies with advertising that is respectful towards you and does not appear to promise sexual activity. For example, there was an agency advertising when I lived in Chicago that called itself "Skanky Whore Escorts." Their ads said, "free blow job for every caller." When I first saw the ads, I thought it was either a joke or a really bold police sting. The ad kept appearing month after month, though, so apparently it was a real business and they were making money. While making money is a good thing, you should seriously consider before applying to an agency such as this. Escorting is dangerous enough as it is without working for an agency that advertises its workers as "skanky whores," insinuating that the services are cheap and low-class. And while "free blow job for every caller" might mean that the phone operator would blow in your ear, this ad sends a dangerous message. Callers already know that they are calling a sex service. Advertising this obvious just encourages the police to take interest and sends the message to potential clients that these are women that do not require respectful treatment.

You'll find that most ads start to look the same after you've looked at a lot of them. They all have similar names with words like "discreet," "elegant," "classy," and "upscale" in the names. The display ads usually have a line drawing of a well-dressed woman. This is the standard to expect – an ad that gives the client a feeling that he's about to get something special and luxurious. When choosing which agencies to call, you may as well list them in

alphabetical order. Companies call themselves "AA Adorable Escorts" so that they can get listed first in the phone book because chances are that the client will start on the first page and call his way through the ads until he finds a date. When you're making your list, give the companies with display ads preference over basic listings for the same reason. Companies with display ads get more business. Likewise, a company that is willing to spend more money on advertising probably makes more money and cares more about their business.

One final thing to note when compiling your list of possibilities is online reviews. There are several sites now that review independent escorts and escort agencies. Bear in mind that sometimes a client makes a negative review out of spite, but if you see a large number of negative reviews about an agency, cross them off your list. Much of the business has gone online these days and whether the review boards have an overall influence or not, they're still a good place to gather information.

Now that you've got your list, start by calling in the afternoon. Most agencies will be closed in the afternoon, although you shouldn't be too surprised if you get a live human voice on the other end of the phone. This preliminary afternoon calling session is mainly to eliminate more agencies from your list. If you get a recording telling you that the number has been disconnected, cross that agency off your list. If you get a recording that sounds like a phone sex line, cross the agency off your list. What you're looking for here are agencies that have a pleasant, businesslike recording on their machine during off-hours.

If you get any live humans during this stage, skip straight to the job application stage. Otherwise, just make a note for your records and move on down the list. Don't bother leaving a message on any of the machines because it's very rare for an agency to call you back if you're not already working for them. They're usually busy enough with their own work and figure that you'll

call back when someone's on the phone if you really want the job. If you get a phone that just rings and rings with no answer, leave it on your list but make a note of the fact that they have no answering machine because that counts a point against their professionalism score.

Now that you've got your new-improved list, which should be greatly reduced in length from your original list, start from the top again and make your calls again, this time in the evening when the agencies should be open. Agencies open at various times of the evening, but you should be able to get through to a live person between 8:00 pm and 11:00 pm. Don't be surprised if the person on the phone can't talk long or if they put you on hold. They are busy taking calls from clients during this time so you don't want to beat around the bush too much or waste their time in any way. Get right to the point. "Are you hiring?" is a good place to start.

Most of the agencies you call will be hiring. Some may not. A good agency doesn't want to keep too many workers at any given time because it's too difficult to keep track of where their workers are and the escorts will get restless if there aren't enough calls to go around. If the agency isn't hiring, don't pressure them. Thank them and move to the next agency on your list. If the agency you've reached is hiring, what happens next may vary. Some agencies will take your name and number and have an owner or manager call you back later. Some agencies will give you another phone number to call. Some agencies will start taking your information right there on the spot. Some will make a date to meet and discuss work. Some will ask you to come right into the office on the spot.

The query phone call will be similar to the one described in the chapter about Nevada brothels. You'll be asked what you look like and whether you have any experience with escorting or not. Be honest about your looks, but don't be afraid to sell yourself a

little. As for experience, be honest about whether you have experience or not, but don't discuss sex or illegal sex work at this point. The agency wants you to be cautious just as much as you want them to be cautious, and any reputable agency will hang up on a girl calling about work if she starts mentioning that she gives a great blow job or has worked as a prostitute. Similarly, you should strongly consider whether you want to work for someone or not if they start talking about sex during the initial phone query. If they'll talk about it with you, they'll talk about it with a client or a cop.

Don't trust an agency that wants to send you on a call before they've had a chance to meet you. That shows a lack of professionalism. They have no way of telling if you've lied about your appearance without meeting you in person first. Any reputable escort agency will want to meet you, either in their office or in a restaurant, to see if you suit their needs. When you go to interview with an agency, dress as if you were going to meet a client. This will give the most professional impression and will also come in handy if they like you and want to send you out immediately.

So how should you dress as an escort? Well, first you should throw just about every movie image you have in your mind out the window. While an escort might be named "Candy" or "Trixie," she shouldn't dress like Candy and Trixie dress in the movies. This means no spandex, no glitter, no thigh-high boots. Save those lovely items of apparel for the strip bar or bring them in your carry-along bag if you want to wear them for a client.

As an escort, you want to be able to walk into a nice restaurant or a quality hotel and blend in. Dress like a professional businesswoman. While you do want to look sexy, your keywords in choosing clothing and make-up should be elegant, classic, respectable and wholesome. You don't want to look like "cheap trash" that the hotel security needs to evict. You should strive to look like a guest of the hotel: a successful businesswoman on her way

through town for a convention. Your shoes should be high-heeled, but not too high. Your make-up should be fresh and well-done but not gaudy. Your bag of supplies should resemble a briefcase or a piece of carry-on luggage. Your goal is to be attractive but invisible. Additionally, choose skirts instead of pants. Skirts convey a classier image and are more likely to be acceptable to your client than slacks.

To make up for your camouflaged exterior, your undergarments should be hot and sexy. Splurge and get matching sets of lacy undergarments. Always wear stockings with garters or thigh-high stockings. If you wear garters, put your panties on over top of your garters so that you can take them off without disturbing your stockings. Get sets in different styles − white lacy innocence, red-hot sleaziness, mysterious black, teeny-bopper florals, elegant silks. You can get by with only a few working dresses at first but you'll want an extensive lingerie collection as soon as possible. Bring extra lingerie sets with you in your carry-along bag in case a client wants to see a different look or you want to freshen up between clients. You'll want a pair or two of spike-heeled shoes with you as well since many clients enjoy the look of stockings and heels in bed. Put your shoes in ziplock freezer bags so the pointy heels don't snag your delicate lingerie.

What else is in that bag? Well, that depends on how you like to work. You will, of course, want to have condoms, lubricant, gloves and plastic wrap to protect your health during sex. You may want to have some "toys" as well. Dildos (always put a condom on your dildo if you use it on someone else), vibrators (I highly recommend the new miniature vibrators that fit on the tip of your finger. They have a stronger vibration than standard battery-operated vibrators but not as strong as the kind you plug into the wall), a few lengths of rope, neatly bundled, a small paddle (one escort I worked with used to carry a paddle-ball paddle with the elastic and ball removed. She spray-painted it black and it

made a perfect light-weight toy with sting and noise but not much bite) or a miniature multitailed whip, massage oil, a box of baby wipes... The more you work, the better an idea you'll have of what things you want to carry around with you.

There's one final thing you'll need for your supplies: a pager or a cell-phone. Eventually you'll want a cell-phone (never say anything illegal over a cell-phone!) but you can start out with a pager. Some escorts will tell you that you need a car as well. That depends largely on where you choose to work. It's best if you have a car, but I worked for years in Louisville using either cabs or agency drivers to get to my clients. When I moved to Chicago, there was no way I could have worked without my own car because the city was too large and sprawling to afford cab fare around town and none of the agencies in Chicago provided drivers. This is usually the case in larger cities; you definitely need a car to work as an escort in a big city.

You've followed all these steps and found yourself a job. What can you expect now? Some agencies will want you to sit in their office while you wait for calls, but most will let you go about your life and page or phone you when they have a call for you. Be ready to go the moment you get a call! You don't have to sit prissily on the edge of your chair, but if you're lounging at home, have most of your lingerie on and your dress neatly hanging, waiting for you. Have most of your make-up on, though you can save lipstick until right before you go out the door to make sure it's fresh and unsmudged. If you're out someplace, make sure that you either have a vibrating pager or you're not in a room that's too loud to hear if your pager or phone goes off. If you miss calls, you'll be branded as unreliable and an agency won't want to keep you.

The agency will call you when they have a client for you. If you're working for an agency that describes each of its girls two or three times with different names and similar descriptions, you'll

be told what name you're working under for that session. I worked for a smaller agency once where the girls were encouraged to get wigs so they could be sent out with any hair-color description. The agency will also tell you the client's name, his address and how long the session will be. Sometimes you are required to call the client directly before you leave, but most agencies will just want you to go straight to the session.

When you get to your client's house or hotel room, the first thing you'll do is call the agency to let them know that you got there safely. Some agencies don't want you to call until you've successfully gotten the client's money, while others want you to call right away no matter what. I preferred to call right away because I often didn't collect the money from the client until after the session. You run the risk of being cheated out of money this way, but it's a lot classier and makes it harder for a cop to prove that you were there as a prostitute. Go by what you feel is right in this aspect and trust your own instincts. Everyone has their own style of working.

How much can you expect for an hour of escorting? The cost varies from agency to agency but I've never seen it dip below $200. Independent escorts also have varying fees, with a low around $130, an average around $300, and a high end that starts around $500 with a limit as high as the sky. Anna-Marie, the "Educated Escort," currently charges $12,000/day with a two-day minimum, but she's raised her prices as she's received extensive press coverage. I remember a time when her rates were about $5,000/day.

Once you've called to check in with the agency, you can go about your business. Some clients will be eager to get to the action while others will want to have a drink first. Some clients are shy and will wait for you to start things. I've found that the best, classiest, most provocative way to start a session is with a hug. It's non-sexual enough to break the ice with a shy client but sexual

enough to let the client know that he can touch you. It's a classy, girlfriend sort of way to initiate sex, but it's not so intimate as an on-the-mouth kiss. It's very natural for hugging to lead to something more intimate so it's a perfect way to get the ball rolling.

Some agencies call you five minutes after you initially call them to make sure that things are going well. I sometimes found this second call annoying and distracting because it often interrupted my client and me just as we were getting comfortable with one another.

Once, though, that five-minute call saved me from having to struggle with a client who seemed normal until I called the agency. After I'd checked in, he became more and more off-balance until I was genuinely afraid of him. I tried to leave but he had security locks on his doors and I couldn't get out without a key. The phone rang and he tried to prevent me from answering it. I told him that it was the agency and they would call the police if I didn't answer the phone. He let me answer it. I told the agency that the man would not let me leave and my manager asked to talk to the client. She told him that I had better call her from a pay phone outside his house within five minutes or she would send the police to his door. He unlocked his door for me and I was never annoyed about the early check-up call again!

Assuming all has gone well with your session, though, the agency will call to warn you it's time to go about five minutes before the session is over. If your client is still going strong, now's the time to re-negotiate for more time. Otherwise, thank him for a lovely time and start getting ready to go. Call the agency right before you leave (or, if you have a cell phone, call them once you're safely back in your car) and wait for your next client.

Depending on where you work, you may have as few as three clients per week or you may have several clients per night. If your agency doesn't send you a client for several days, you should call to ask them if everything's okay. Don't be angry or confronta-

tional, just ask if things have been slow lately. I've encountered some agencies that hate to fire people, so instead they just quit sending them on calls. You need to know if that's the case so you can start shopping around for another place to work.

At some point, you may decide to go to work for yourself. Working as an independent escort is really no more difficult than working for an agency if you know what you're doing. You'll have to take over advertising and client screening yourself, but you'll see the difference in how much money you get to keep.

Read the chapter on marketing your services. As an independent escort, you'll probably want print ads in your local adult newspaper and a web presence. Some escorts choose to work only through the web and, depending on where you are located, this may be a viable option for you. I enjoyed working through the web because I didn't have to answer the phone every evening and I found that the clients I got from web advertising were nearly always high-quality clients. It's also easier to get your clients to give you advance notice of a session if you advertise through the web.

If you do decide to take out a print ad, you will have to answer your phone regularly. Some workers put only their phone number in their ad or say that they are available 24 hours. If you do that, be prepared to have your phone ring at all hours of the day and night. I had regular phone hours when I worked with a print ad and a phone message that told callers when I'd be answering the phone next. Many clients will want you to drop everything and come to see them immediately when they call. Of course it's up to you how much advance notice you require, but it's not a bad idea to be ready to go if you're working in a competitive area.

There are various ways to screen your clients before you go to see them. Some escorts don't bother to screen clients at all – they just go unless they get a bad feeling about somebody. Some es-

corts will require the client to tell her where he works. Others call information and ask for his number or purchase a street directory and look up his house. If he's in a hotel, be sure to get his full name as well as his room number, as some hotels will not let a visitor go up to a hotel room unless she can provide the full name of the guest staying in that room.

Independent escorting offers one variation that agencies don't: the incall date. Outcall means that the escort goes to visit the client. Incall means that the client comes to visit the escort. If an agency offers incall, they are no longer an escort agency, they are a brothel. I know many escorts who offer incall services. Some say they enjoy it because they don't have to travel. Others enjoy the comforts of home. Some like incall because they can charge more money. Since their client no longer has to pay for a hotel room, that money can go in the escort's pocket. Some of the drawbacks to incall work include a greater risk of being stalked by a client, a greater risk of arrest, possible confiscation of your home or property if you are arrested while performing incall services in your own home, and a higher burn-out factor because your home is your place of business.

Some independent escorts set up a safety-net situation where they pair off with another escort and call each other regularly to keep track of where they are. This arrangement works pretty well for those who use it. The only thing you might want to watch out for is conspiracy charges. Anytime two escorts get together to arrange business or trade clients, they are risking a felony charge instead of the typical misdemeanor charge if they are caught working alone or for an agency. Of course, running your own agency also puts you at risk of felony charges.

Some escorts keep records of who they go to see, how much they paid and details about the client's likes and dislikes. While this can be very helpful for your business, it can be used as evidence to incriminate you or your clients. You may have read of

the large escort agency bust in San Diego not very long ago. The agency's client list was on a computer with a doomsday switch that was supposed to erase the information on the hard drive. The switch never got flipped. When the police came in the front door, the office worker escaped out the back window, leaving the computer, and all its information, intact.

A more effective form of doomsday switch is one that is activated when the computer is turned on. Unless a password is entered during the boot-up sequence, the doomsday software goes into effect, erasing, writing over and re-erasing data on the hard drive. The advantages to this type of doomsday switch should be obvious. In the heat of the moment, you don't need to make a decision – just turn the computer off. If the computer is confiscated, the doomsday software will begin its work when the police turn it on to search for evidence. The disadvantage to this method is that the doomsday software will take hours to clear your hard drive. Also, if information has been on the drive for a long amount of time, it will have burned into the drive to such a degree that doomsday software will be useless. Finally, most police departments send their confiscated computers to experts these days. An expert will boot the computer with a floppy disk and circumvent any protections you've set up.

One protection that is difficult and costly to circumvent is PGP protection. You can protect your drive with PGP encryption, and it is very difficult and time-consuming to crack the encryption without the key. A drawback to this method is that it may increase the severity of your crime. In some countries it is a national crime to withhold a PGP key from a government official. At the time of writing, this is not the case in the United States with the exception of cases where a person has been granted immunity from prosecution in exchange for revealing incriminating information. If you choose to investigate encryption

software and software that wipes your hard drive, you may want to look at the McAfee line of products.

I know of one worker who could have used some protections in her computer. When she was arrested, the police confiscated her computer and were able to read her e-mail. Through clues provided in her e-mail, they went on to arrest several more workers in the same city.

Of course, if the police want your info badly enough, they still can get it. It will be a pain in the ass and they will have to spend extra money, but they can read your hard drive no matter what you do. Any encryption or attempts at drive wiping will just throw the casual cop off the track. The biggest drawback to protecting your information is this: encryption and drive-wiping make you look like a bigger target than you may actually be. Taking strong measures to protect your information may make the police decide that they've arrested more than just a penny-ante prostitute but rather a hub in some grand intrigue. There are times when it's better to just let the chips fall where they may.

As a friend once put it to me, "if you're going to commit a criminal act, think like a criminal. Cover your tracks, but don't be stupid about it." Mind you, I'm not advocating criminal activity – I don't want any of my readers to break the law. What you choose is your decision. But whatever choices you make, please be wise in implementing them.

For More Info

Yahoo: Escort Directories
http://dir.yahoo.com/Business_and_Economy/Shopping_and_Services/Sex/Adult_Services/Escorts/Directories/
A collection of links to various escort directories where you can advertise your services.

How to Use Escort Services

http://sex.perkel.com/escort/index.htm

While written from the client's perspective, you'll find much valuable information in this article.

Escort Services: Legal Issues

http://sex.perkel.com/escort/legal.htm

Marc Perkel (author of *How to Use Escort Services*) provides a legal brief explaining why escorting is not prostitution. While his arguments may not protect you in court, his article is worth reading.

NEVADA BROTHELS

P rostitution has been legal in Nevada since Christmas Day, 1970. A brothel owner had been paying $1,000 per month since 1967 to keep his brothel open and the state decided to create legislation to explain where that money was coming from. Thus brothel licensing was born.

In 1971, another law was passed, forbidding prostitution in counties with a population over 200,000. This second ordinance was intended to keep prostitution out of the tourist areas such as Reno and Las Vegas. Legal Nevada brothels are found on back roads near junkyards and nuclear testing sites – far off the beaten track to avoid offending local citizens and tourists as much as possible.

There are currently over 30 legal brothels in Nevada, grossing an estimated 13 million dollars per year from something along the lines of 350,000 customers. Not all of this money ends up in the workers' pockets: some customers just come in to look around and have a drink, never purchasing services, and when services are rendered the workers keep less than half of the money.

Like any field of sex work, the legal Nevada brothels have their pros and cons. It's definitely amusing to openly flirt with potential clients while the county sheriff is sitting three seats down from you at the bar, but with legalization come regulations. While some of the regulations appear to be necessary, many of them are quite restrictive.

Most brothels are surrounded by locked fences with a doorbell by the gate. The fence is allegedly for security purposes but don't count on the fence for protection – I've seen troublemakers climb over the fences before! The real reason for the fence is to make it easier for management to keep track of who comes and goes. Some brothels also have bars on the windows, again allegedly for security. Many women who've worked in brothels with bars on the window say it feels as if the real reason for them is to keep the girls from running off.

Nevada brothels come in a variety of sizes and conditions. Some are run-down and seedy-looking, while others are beautifully decorated and well kept-up. More and more of the seedy brothels have been putting money into renovation these days. The face of legal prostitution in Nevada has changed since the Internet and news coverage has brought more attention and more money to the brothels. The largest brothel I've seen had over 30 rooms for workers. The smallest had only two. Most Nevada brothels are built around adjoining trailers, although you wouldn't realize it in many cases.

Each brothel has individual rooms where the workers transact business. Most brothels have sinks in each room, though some don't. You might have a bathroom all to yourself, one shared with another room, or a single bathroom shared among all the rooms, depending on the brothel. There will also be a general parlor or bar area, and some brothels have hot tubs, areas with dungeon equipment for SM and fetish parties, or other little extras. A session with a client is called a "party" in the Nevada houses and the clients are generally called "gentlemen," "visitors," or "guests." Most brothels frown on words like "whore," "john," or "trick," though the workers may use these words privately among themselves. It's advisable to wait and see what sort of language is acceptable before using words that might cause trouble for you.

One of the more luxurious aspects of working in a brothel is the large support staff you'll have. Most brothels have: Cooks to prepare meals two or three times a day. Bartenders to mix and serve drinks. Housekeeping staff to vacuum, scrub toilets and do the laundry. Bookkeepers to keep track of your earnings. Runners to get you from the airport, pick up toiletries for you and more. Booth workers (the title of this job varies from house to house) to hold your money, watch your time and alert you via intercom when your party is almost over, hand out clean sheets and towels and listen for sounds of trouble from rooms. Floor maids to keep everything running smoothly in the parlor. The Floor Maid watches to make sure that nothing illegal takes place in the parlor, she lets the clients in and out and introduces them to the workers, she sends workers to their room if they are too drunk or presenting a problem in some way. She will listen to troubles and help when she can. She's a lot like a dorm matron or a den mother. Often older prostitutes become Floor Maids but just as often, you'll have a Floor Maid who's never worked as a prostitute herself.

Some of these workers are paid for by your room and board while others, like the runners, must be paid for out of your pocket. In at least one brothel that I know of, workers must also pay for their food, per item. As in most areas of sex work, it's a good idea to tip your service staff. In most brothels, the staff makes minimum wage with no benefits. Regularly tipping your staff helps secure good service from them.

Generally speaking, there are two different "parlor styles" in Nevada. In both the Northern and Southern houses, the available workers all line up when a visitor arrives. In the Southern houses, the gentleman is sent away if he does not choose from the line-up. Sometimes he is sent to a bar next door to the brothel where he can have a drink and think about his options. In the Northern houses, if a gentleman does not choose from the line-

up he can sit in the parlor and have a drink while he waits for the workers to approach him. Either system has its good and bad points. If you don't like to mingle and socialize with strangers, you might decide to try for a job at a Southern brothel. If you feel that socialization is your strong suit, you might consider a Northern brothel.

Let's look at a typical party from start to finish. Some details may vary from brothel to brothel, but you'll find that most elements of brothel work are standard wherever you go.

When a client rings the doorbell at the front gate, the Floor Maid pushes a button to let the client into the brothel and also might push another doorbell to alert the workers. She'll call out "company, ladies!" – over an intercom if the house is very large. All the workers line up, smile and hold still.

I'm told that the Southern houses are stricter with their workers about fidgeting in a line-up than the Northern houses are, but I think that it really just varies from house to house, depending on management style. Generally, though, it's considered to be in poor taste to sashay about or do anything to call special attention to yourself when you're in line-up. There can be a lot of competition between the workers, and "dirty hustling" is a good way to make some enemies. While you're not there to win a popularity contest among your co-workers, you definitely don't want any enemies if you can avoid it. Most brothels don't have locks on the doors to the workers' rooms (other than keyed locks that are used by the housekeeping staff) and you will have to live and work with any enemies you might make. Be assertive, but be tactful and cautious.

Once everyone is lined up, the Floor Maid will welcome the guest and say something along the lines of, "I'd like to introduce the ladies we have working tonight." Then, one by one, each worker will say her name and nothing else. It's very important to smile and make eye contact when you say your name. I've watched

some very beautiful and friendly girls blow it time and time again by looking bored in the line up. You may think that the dusty farmer standing there doesn't have any money, but you never know. Sometimes the most unlikely-looking clients have been the most lucrative for me.

So, you have been chosen from the line-up. Now it's time for the "tour." You'll lead your client back to your room, stopping along the way to show him the hot tub room, dungeon or V.I.P. room if your brothel has any of these extras. Engage him in a little chit-chat as you go. You might ask him where he's from (if he's local, you might end up with a regular client), what he does for a living (this gives you some idea of how much money he might be able and willing to part with), or if he's ever been to your brothel before (this is his chance to tell you if he's never done "anything like this" before). Once you get him back to your room, have him sit on the edge of the bed or on a comfy chair if you have one. Now it's time for the negotiation.

As much as I'd like to give you a simple formula for negotiation, the truth is that each woman develops her own style and each man presents a different challenge to her negotiation skills. To be honest, this was always my least favorite part of the job. I have a soft heart, but I want to make a good living at what I do. There were so many times that I wished the house had set prices and that someone else would deal with money so I could just do the part I liked best, which was to be sweet to men and make love to them.

But the reality of the situation is that you will have to be a shrewd businesswoman and then immediately switch to a loving prostitute. I'm sure the transition is not much easier for the client who has to stay on his guard to keep from being swindled and then return to an amorous state. Okay, maybe it's not hard for him at all. Heck, what do I know? Maybe it's not hard for you, either. But if you do find yourself having a tough time when it comes to the money, know that you're not alone.

One style of negotiation – the one that worked best for me – is to begin by hugging your visitor. If you're comfortable with kissing clients, you might want to do that as well. It will seem as if you are giving away attention, affection and favors for free, but what is actually happening is that you are giving him a small taste of what he can expect from you. Don't go too far with it... though how far is too far? If you choose to use this technique, you will gradually learn what the right limits are for each man. I never took it beyond a hug and kiss, but I have heard fairly reliable rumors from several sources that another worker – one who made far more money than I did – would frequently let a man lick her pussy for a moment before discussing money. It obviously worked quite well for her, but I was too insecure to go so far before discussing money.

Once you're sure you've got the guy's interest, you ask him a very obvious question, "what would you like to do?" Some men will spell it out for you while others will just smile and moan. Then you briefly bring him back to reality with, "well, we need to give them some money so we can relax and have some fun."

At this point, your gentleman will likely have one of three responses. He may hem and haw, in which case your negotiation will probably get tricky, as he either doesn't have enough money or is very nervous about paying you. He may name a dollar figure and ask, "is that enough?" at which you'll either reply, "oh yes, that will do," or "actually, we'll have a better time if you've got a bit more," depending on what amount he names. Or he may ask you directly how much money you need. If he asks you, your best bet is usually to put the question back on him with, "well, what have you brought for me?"

Part of the secret to making this technique work is making him be the one to name the price. The majority of men who go to Nevada brothels already have a good idea of what the going rates are. They've either visited before, researched it on the

Internet, asked a friend, or called a house and asked how much money they should bring. If a man tells you, "well, it was that price when I was here 20 years ago," tell him, "inflation takes its toll yet again." If he tells you, "the girl at the other house will do it for less," tell him, "I am not her." And if he tells you that he's never been before and honestly had no idea how much it would cost... and if you sincerely believe him, tell him a reasonable price that's higher than what you'd settle with.

No matter what you do, never start with your asking price. I tried that for a while when I was in the process of discovering my own negotiation style, and I quickly learned that men will never believe that your rock bottom price is anything other than a negotiable sum. If you name a price, your client will nearly always try to talk you down to less. This was needlessly frustrating for me – I'd never dealt with a situation where the cost of my services were constantly under negotiation before and I was not used to working that way.

This leads us to a different negotiation style that works for a lot of women. This is more of a "hard sell" technique. Some women will sit close to a man and cuddle while going through this sort of negotiation and others will not – as with many aspects of Nevada prostitution that take place behind a closed door, there is much room for personal expression. When discussing money while using a hard-sell technique, the worker may try to get her client to name a price first. But if he doesn't, or if the offering price is too low for her tastes, she will counter with an offer that is astronomically high. Some men will walk out immediately at that point, while others will reassess their opinion of the worker's worth. There are many people who do not believe that a product or service is of high quality unless it comes with an equally high price tag.

A selling prop that can assist in the hard sell is a brothel menu. Many brothels publish their own menu, or a worker can exert

some creativity and create her own. The brothel menu lists many different sexual activities, often labeled like a restaurant menu as "appetizers," "entrees," and "desserts." Each activity has a price tag attached to it and each price is very high. The idea is that some men will pay the menu price because they don't know any better while other men will try to negotiate the price down to something more acceptable to them. Either way, the worker starts off at an advantage.

By the way, just as different women have different negotiation styles, there are also two main different styles of partying. There is the "á la carte" method, which works well with a brothel menu because each act, sometimes even each position, is independently negotiated for. If oral sex was not specifically negotiated, oral sex will not take place. If the doggie style position was not negotiated for, good luck getting her on her hands and knees without handing over more money. Generally speaking, it is easier for an extremely attractive woman to get away with hard-sell negotiation and á la carte services.

The other method, the one I and many other very successful workers used, is more of a "table d'hote" style. In this style, an amount of money is equal to an amount of time rather than a list of activities. If I felt I'd been paid honestly for a half-hour of my time, I'd do anything, within reason, that was requested of me in that time allotment. Oral, multiple positions, even multiple orgasms if my client were the sort of man who can go more than once in half an hour.

While an á la carte worker will tell you that you've cheated yourself out of money by being too willing to oblige, I think that a table d'hote approach is actually more honest to the client, because the á la carte worker will often cut activities short after a specific time period, even if her client has not climaxed. The client is rarely informed that his á la carte party also includes a time limit, and many times I have talked to clients who came out of an

á la carte party feeling cheated. Even worse, an á la carte party holds the possibility of leaving your client feeling emotionally alienated. An emotionally unsatisfied client will rarely return to give you repeat business. While drop-dead gorgeous porn stars can survive off single-party clients, the average worker needs repeat business in order to succeed as a prostitute.

Now that you've got his money in hand, it's time for the D.C. or Dick Check. You can find complete instructions for that in the chapter on Safer Sex. Be sure to read that chapter – it's got some of the most important information you'll need in your sex work career!

Some houses will want you to bring your visitor up to the window with you when you turn in the money. This is to prevent workers from keeping a portion of the money themselves and reporting a lower amount to the house. Other houses will tell you to leave your gentleman in your room while you hand in your money. I've found that the clients feel more comfortable waiting in your room, but many workers also have troubles with clients stealing lingerie from them while they're left alone. Either system has its benefits and drawbacks.

Once at the window, you hand over your money and request a "set-up," which is usually a clean top sheet, a clean towel and a clean washcloth. The booth worker will get your time card out and write the amount of money on your card along with the time. If this is a house where the booth worker also helps you keep track of time (some houses will leave that to the workers), you'll tell her how much time you'd like. Once all that is taken care of, go back to your client who is impatiently waiting for you.

When you return to your room, adjust the lighting and turn on some music if you have any. You'll need to wash him now, so either have him take his pants off or, if you really want to be sexy, take his clothes off for him. Take off his shoes first. Not only will you need to have them off in order to get his pants off, but there

is something psychologically fulfilling about having someone else seductively remove your shoes. This action tells him that you are truly here to serve him and will make most men feel pampered.

Take his pants off and prepare a bowl of warm water with a few squirts of antibacterial soap in it. While your gentleman is standing, put the bowl beneath his penis to catch any drips and gently but thoroughly wash him with a washcloth. Set the bowl aside where it won't get kicked over – if there's a sink in your room, that's the best place for the bowl – and dry him with the towel. Finish undressing him and either allow him to undress you or strip seductively for him and you're ready for action.

If you're like most women, I don't need to tell you what to do next. Have sex with him. Make him feel special. Try to enjoy yourself as well – just because it's work doesn't mean it can't be fun!

When you're finished, clean him up again. If you've had a short party, the bowl of water should still be warm. Otherwise, heat more up. Gather up your linens and drop them off for laundry as you walk him back to the parlor. Give him a little hug and send him on his way with a smile on his face that will make every man in the room want to visit you next!

So you're ready to try life in a brothel – how do you go about getting a job there? You screw your courage to the sticking place and give one a call. Be honest with the person you speak with on the phone. Tell them how much experience you do or don't have in sex work. They're used to "turn-outs," people who have never done any form of sex work before, and they won't be judgmental towards you if you've been working as an illegal prostitute for years as long as you don't have a recent criminal record or a felony conviction.

The person answering the phone will usually not tell you if you're hired or not – if they're interested, they'll tell you to come out and give it a try. Understandably, they don't want to commit

to a person without meeting them unless you're already a known porn star. They'll usually ask you to describe yourself. Of course you can't lie because they'll know the truth when they see you, but you are expected to "sell yourself" when you tell them what you look like. They don't just want to know if you're physically attractive, they want to know if you can present yourself with confidence.

Give your height, weight and measurements if you feel comfortable with that, but most times you don't even have to do that. For example, I'm what's known as a "BBW" (big beautiful woman) so I usually don't reveal my weight – not because I'm embarrassed about my weight but because I realize that most other people don't translate "200 pounds" into the reality of the beautiful, shapely woman that I am. I know that I am beautiful and that men will pay money to have sex with me and that is what I project when speaking on the phone to a brothel employee. Here's how I would describe myself when asked: "I'm average height and very curvy with triple-D breasts. I have soft auburn hair past my shoulders, hazel eyes and full, sensual lips."

Learning to accentuate your best features and present yourself well is one of the most important aspects of sex work. Every woman has issues with her body image. Every woman has some body feature they want to hide or change. The secret, though, is that most people won't notice your flaws if you pretend they don't exist. When I was a child, my mother told me, "if you feel uncomfortable in a situation, just pretend you're supposed to be there. Most other people are too worried about how they look to notice you if you act like you belong." She was right about that even though she had no idea at the time that I would use that advice in practicing sex work!

If the brothel is interested in trying you out, the phone person will ask you when you plan to arrive so you should try to already have an idea about your travel arrangements when you

call. They'll write down your arrival date and time (or tell you to call them back with that information) so that they can plan to have their driver pick you up from the airport. Once you get to the airport, call the brothel and expect to wait for your driver. Very rarely has a driver been waiting for me at the airport, and usually then only because he was already running some errand in town. I used to commute from Chicago to Reno and it would take me less time to fly there than it did for the house to send someone to pick me up at the airport, even though they already knew what time my flight would arrive.

The driver will probably take you to the doctor for your bloodwork on the way from the airport to the brothel. The house you choose to work for should tell you how much the initial doctor visit, licensing cost and runner's fees are when you talk to them on the phone before coming out. Save your doctor receipts! They're deductible as a required business expense. Because you have to register to work, you can't expect to be able to evade your taxes. The house will have you fill out tax papers and your income will be reported to the I.R.S.

After you've had your bloodwork and a pelvic examination, the driver will often take you straight to the sheriff's office for your license. Be very polite to the person who takes your information and fingerprints you. In most counties, there is only one person who has jurisdiction to award or deny worker's permits, so you don't want to get on their bad side. They will ask you about your criminal history, check a photo I.D., fingerprint and photograph you. You can't get licensed if you have ever been convicted of a felony, if you have legal issues currently pending or if you were convicted of prostitution any time, anywhere in the last five years. If you move from one house to another house you will need to get re-licensed even if you are just going next door. A brothel work permit is house-specific and gets kept in the office of the brothel where you work.

You won't be able to go "on the floor" until the results of your first blood test come back, usually overnight. Once you've been verified and licensed to work, you'll have to see the doctor once a week. Most houses have a circuit doctor who comes around one day a week. If your house doctor comes around on Wednesdays and you had your initial bloodwork done on a Tuesday, you'll have to take the day off until the doctor comes in if you want to get on the house schedule. Being on the house schedule is advisable because you don't have to pay a runner to take you into town to see the doctor every week if you see him at the house. The doctor is only required to take blood once a month but you must have a pelvic exam every week.

If you are used to escort work, brothels will be a tough change for you because you don't usually get as much money per hour since you have to split all your money, including tips, with the house. In most brothels, you'll tend to make up for the difference with volume of customers. Different girls charge different prices; most of us don't have set prices but use skillful negotiation and the ability to read people to secure as high a fee as we can.

Expect to be able to charge an average between $200-$600 per hour for straight sex and/or oral, more for fetish sessions and spa room sessions. Most houses have minimums around $60 or $100. The least I ever charged for a party was $50 for a 15-minute blowjob. The most I ever charged was $1000 for a two-hour session. My philosophy was to accept the cheaper parties as long as I felt comfortable with the person. It's a philosophy that paid off because there were days when I'd get four short parties while everyone else was holding out for the expensive parties. At the end of the day, I'd have more money because of my philosophy.

An independent survey of online brothel clients conducted by the Georgia Powers website found that in 1997 the average amount paid per hour was $335, with median $300 per hour and standard deviation $140 per hour. Eighty-nine percent (89%) of

all surveyed parties fell in the range of $150-$500 per hour. These statistics were for parties that included vaginal intercourse – not all parties do. The same survey, when conducted again in 1999, had nearly the same results: 90% of the sessions had a cost rate from $150 to $500 an hour, with average $301 an hour, median $260 an hour, and standard deviation of $131 an hour.

Before you start multiplying $300/hour by the number of hours in the day, there is something you should know. Some days even the most beautiful woman in the brothel doesn't book a single session. Even more frustrating, that gorgeous woman who's having a bad day might be surrounded by plainer-looking women who are booking four or five sessions each. That's the sex industry for you – you never know when it's going to be your day!

With some idea of the money coming in, let's look at the money going out. The biggest expense comes right off the top: the house will keep 50% of all the money you earn. Next comes your room and board fee. Some houses will give you a break if you book a certain amount: for example, book over $1000 in parties and your room and board is free for that day. The average room and board fee is about $25. On top of all this is the "Kelly fee." A "Kelly" is a client who arrived in a taxicab. (Some houses have different names for Kellys.) The Floor Maid will usually warn you when you take a Kelly back to your room by yelling "Kelly" in your general direction. It's important to listen for that word because an extra 20% of your earnings will go to the cab driver!

Along with these daily expenses, you'll have the weekly expense of medical examinations. The bloodwork for the Carson City/Reno houses cost $85 when I was working there last year. I'm told that doctor visits cost a few dollars less in Southern Nevada. A doctor visit that doesn't include bloodwork is around $50, depending on the area where you work. I spoke to a brothel manager in Southern Nevada who said the weekly visits there

were only $35 but that was a tiny brothel in a remote stretch of highway that only had room for two girls at a time. Some houses will let you charge your doctor visit if you're low on money that day, but it's rare for a house to let a worker charge her initial doctor visit. The house I spent the most time at added a $20 fee for charging the doctor.

Finally there is the yearly expense of licensing. The cost of licensing varies from county to county but is approximately $50 per year. The house you choose should be able to tell you the exact costs of all these expenditures over the phone. In addition to all these costs, don't forget your transportation fees. On top of what it costs you to take a plane or bus to the area, the house runner will charge you to pick you up at the airport. Again, this cost varies from house to house. I paid $30 when I was working in the Reno/Carson City area. The runner will also charge you if he has to go get supplies from the store for you. That cost varies, but expect it to be around $5-$10. If the runner takes you to get your license on a separate trip, that's another $10 or so.

As you can see, a brothel is an expensive place to work! Why do women tolerate all those fees? Usually because it's legal, it's off the streets and they feel safe in a brothel.

Some houses make the girls work twelve-hour shifts (14 hours on the weekend) and some houses have their girls work around the clock – as long as there are customers, she's on duty. Some houses will make you stay on site for ten days when you first show up, without even letting you leave to go to the store. Some houses will make you live there – the local law forbids allowing prostitutes to go to stores or bars in the town. Some houses will let you get an apartment or house nearby and go home after your shift. Working in some brothels is like living in a palace, while others have nearly intolerable living conditions. This is why it's best to try to talk to other workers to see what they think of a house before you decide where to work.

I commuted to the brothels from Chicago. When I was doing that, I'd work two weeks and go home two weeks. Be firm about the schedule you want – most places will give it to you if you are a good worker. The whole time I was commuting from Chicago, the manager kept trying to talk me into working three weeks and I told her that there wouldn't be much point in going home for a week since two of those days would be taken up with travel. If you work a schedule like that – the two weeks on, two weeks off – you probably want to go ahead and work all seven days of the week while you're there. For me, that meant an 88-hour work week.

If you have an aversion to living around people who use drugs, you might have a hard time in the Nevada houses. They try to keep drugs out of the houses and the majority of the workers are clean, sober, intelligent women, but there are almost always pot smokers and generally at least one user of harder drugs in each of the larger houses. Usually if you mind your own business and try to be friendly to everyone while maintaining your boundaries you won't have trouble. There can be scary moments when you're living in a dorm-type situation with people who do drugs. Bring a padlock – there are no locks on the room doors in most brothels, but they all have closets with a hasp on the door for you to lock your money and valuables inside.

Ask the person you get on the phone at the house if they have any special dress regulations. I know that some houses require evening dresses after a certain hour, for example. Other than that, just use your imagination and dress in a way that is sexy but not too revealing. The parlor is still considered a public place so you have to keep all your "naughty bits" covered in there. I usually wore things like a black teddy with a long black silky skirt over it and a black lacy jacket or lingerie with a sheer or lacy long robe over it. Different people have different styles so try to develop your own memorable clothing style that fits your personality. And

when it comes down to it, personality is your biggest overall asset. Allow yours to shine through when you're working and your clients will remember you and return for more.

Legal prostitution has its good and bad points, like any other job. Pay attention to business, don't get involved in petty intrigues, and try to be a decent person, and you may find brothel work suits you so well you stay for years.

For More Info

Georgia Powers's Bordello Connection
http://www.gppays.com/
This is the main site for Nevada brothel clients. There is a message board where clients discuss all aspects of Legal Prostitution in Nevada (LPIN) and workers are welcome to join in. There is also a vast collection of "field reports" about various brothel workers and "special reports" about aspects of LPIN that can be of great interest to newcomers.

64

nevada brothels

THE ADULT MOVIE AND
MODELING INDUSTRY

I'll be honest and admit that my personal experience in adult movies is limited. I have more experience with nude modeling, having been shot for magazine layouts and private portfolios many times. But I had a small, non-sex role in one porn film and was allowed to watch other actors as they filmed their scenes. Among my personal friends are porn actors, romantic partners of porn actors and an editor of a professional porn review. So while I can only speak a small bit about what I have experienced in the movie industry, I am able to share what I have learned from others who have spent, in many cases, their entire adult lives in erotic film.

One of the first things to consider before seeking a job in porn or nude modeling is how you will feel if your parents see a picture of you or a film of you having sex. How will you feel about these images 20 years from now? How will you feel if you find yourself facing difficulty getting a non-porn job or finding a spouse because of your involvement in porn? Unlike dancing or prostitution, where you might be able to hide your past from most people, porn films and adult magazines have the capacity to haunt you with physical evidence of your sex work. If you think you might ever want to live a "straight life," then forms of sex work that document your involvement may not be for you.

The second thing to consider is location. While porn movies and magazine layouts are filmed in a variety of locations, the bulk

of the available non-amateur work is in Southern California. Are you prepared for the travel expenses or relocation expenses? Relocation is not an issue if you just want to try porn out for a short while, though. As the Porn City News puts it, "If an attractive girl with a nice body (say a 6 or higher on a 1-10 scale) comes to Los Angeles for a week, she can make two adult videos each day for the whole week if she wants to. Then she goes home and counts her money. She won't be rich, but it'll probably be more money than she could make in six months otherwise."

With the exception of submitting polaroids to the amateur sections that most adult magazines have, going straight to a magazine is the method least likely to get your foot in the door. If you want to be a magazine model, your options mainly boil down to working with an established photographer, working through a talent agency, or breaking into magazines by starting with a movie career.

Some women start out in "amateur" porn. Amateur does not necessarily mean that the film was made in a newbie's living room with a camcorder and a tripod. Amateur refers to a style of film, setting, actor and "script." There are some larger companies producing and marketing stacks of amateur films yearly. While amateur film does not pay as well as professional – and often doesn't pay at all – it can be one way for untried actors to find their way into professional films. Expect to make about $100 (or less) for an amateur film performance unless you have a large amount of capital and are equipped to produce and market your own videos.

Working as a professional porn actor is hard work. I watched two women and a man have sex for several hours. The room was hot and crowded, they had to stop and start innumerable times as the director had them change positions or pose for publicity stills. Towards the end of the shoot one woman, who had never been in a porn movie before, got so disgusted at the sight of the man having anal sex with the other woman that she kept trying

to walk out of the room. The final scene as it appeared in the movie lasted less than 20 minutes.

Most porn movies are shot in one day, from dawn to dusk and sometimes far into the night. Some movies take as long as three days to shoot while other times a director can shoot two movies in one day. An unknown female actor getting her start can expect to earn about $200 - $500 for a scene. There are no royalties for magazine models and porn actors. You'll get a one-time performance fee and the company then gets to sell your image as much or as little as they choose.

Although an actor's earnings will go up if her work is appreciated, sometimes topping $2000, some producers try to use a variety of actors these days to avoid creating more of the "megastars" porn saw in the Seventies. On the bright side, it is far easier for a female to break into porn acting than a male, and the porn industry employs far more female actors than male. Only four or five new male actors enter the porn industry each year! Still, there are only a few hundred people at any given time in the pool of mainstream porn talent, so it's tough for anyone, male or female, to break in at the top. There are literally hundreds of beautiful women trying to break into porn. The competition is fierce!

In addition to making money from scenes in movies, most porn actors also do hard- and softcore magazine layouts, Internet photo layouts, catalog product demonstrations or endorsements, appearances at adult bookstores, conventions and other adult events, and feature dancing. Although producers often like to "spread the love around" by using a variety of actors, an attractive woman who treats the job like a real profession can usually work as much as she wants to.

There are only two licensed porn talent agencies. These two agencies, both in Los Angeles, are licensed to act as employment agencies and they will connect talent and producers. The actors or models are paid by the company they work for and the agency bills

the company separately for providing the introduction. One of those licensed agencies is Pretty Girl International (310-550-1155, 323-882-8262) owned by Reb Sawitz, and the other is World Modeling Agency (818-986 4316), owned by Jim South. WMA recruits talent for both movies and magazines and Jim South is generally considered to be the most reputable agent in porn today.

There are many other agencies, both above-board and sleazy, who are not officially licensed. These agencies will usually call themselves "managers," "casting directors" or various other titles to get around the agency laws. Among the non-licensed agents are Beautiful Models International (310- 207-4622), owned by Regan Senter, Lucky Smith and David Woodrow, and Star World Modeling (818-255-0065) owned by Rob Spallone. I can't say which of these you should seek or avoid – ask around and keep your eyes open.

Beware of the "casting couch" method of some "agents." Some less scrupulous managers will perform a "screen test" on their new talent, having sex with them on film and then selling collections of the clips. The casting couch may or may not get you work – but why risk it when there are plenty of agents who will get work for you without sampling your wares first? The casting couch appears to mainly be a way for some people to make money off free talent.

Whether you appear in movies or still pictures, you will be required to sign a model's release contract. If you have not signed that form, no one is legally allowed to use your photos. Be sure to read your contract carefully! Don't sign it if there's anything there that rubs you the wrong way. One of my colleagues told the story of what happened to her when she signed a bad model's release:

When she first started modeling, she didn't read the model's releases before signing them. She signed a release that said that the photographer could do whatever he wanted with her image. Before she knew it, there was an inflatable sex doll made in her

image. The doll had her professional name attached to it. She had never authorized the doll, nor did she ever receive royalties for it. She tried to fight it, but there was nothing she could do – after all, she had signed a legal contract. Her advice to others: read your contract and cross out anything you don't agree to. Get a copy of the contract for yourself in addition to the one your photographer will keep. Make sure the photographer signs both copies, adding his or her initials next to every one of the corrections.

Due to concerns about AIDS, most directors require their actors to be tested for HIV before a film shoot. The AIM Healthcare Foundation has developed to test actors and serve as a clearinghouse of health info for adult actors in general. The "safer sex" adult film is another response to HIV concerns. There is still some resistance to safer sex adult films because it's believed that the end purchaser does not want to view sex with condoms, but more and more safer sex films are being produced. An actor can hold out for safer sex films if she chooses. There will be fewer films available to choose from, but an actor can still make a living, especially if she also does photo shoots and works as a feature dancer.

For More Info

AIM Healthcare Foundation
http://aim-med.org/
The Adult Industry Medical Healthcare Foundation. A nonprofit corporation created to care for the physical and emotional needs of sex workers and the people who work in the Adult Entertainment Industry.

World Modeling Agency
http://www.worldmodeling.com/

A small site with contact information for scheduling an appointment.

Beautiful Models International
http://www.beautifulmodels.com/
This site includes pictures of the agency's models, protected by an Adult Verification System, and an online model application form.

Porn Star Jobs
http://www.pornstarjobs.com/
An online talent agency.

Porn City News
http://www.porncitynews.com/

Adult Video News
http://www.adultvideonews.com/

Porn News Daily
http://www.pornnewsdaily.com/

Fetish Work, Domination and Submission

"**B** oy, I'd love to kick the shit out of guys and get paid for it. I have a lot of anger towards men so I think I'd be a good dominatrix."

"I want to be a dominatrix because it's so much easier than prostitution. I wouldn't have to have sex with them but I could charge as much as if I did. The money would just fall in my lap!"

Despite its current alt-mainstream appeal, professional domination and submission is as swathed in mystery as any other form of sex work. Fetish work seems to attract an inordinate amount of get-rich-quick hangers-on and money-for-nothing pipe dreamers. I've noticed that a lot of people seem to think of domination as the easiest form of sex work. In truth, it's one of the more difficult arts. To be a successful professional dominatrix, a worker needs more skills, more experience, more tools and more resources than nearly any other form of sex work.

Why do people think it's so easy? Possibly because the dominatrix does not have sex with her clients. Many people find the physical intimacy to be the most intimidating factor of sex work and domination offers a chance to charge the wages of a prostitute without doing the job of a prostitute. However, having sex with clients is simple compared to the job of a professional dominatrix or submissive.

Before we even touch upon skills and experience, there are countless props and accoutrements that a successful would-be dominatrix or professional submissive needs. The dominatrix I worked with in Chicago had spent thousands of dollars on her dungeon, equipment and clothing. Setting yourself up as a professional fetish worker is not cheap!

You'll need a place to work your magic. While Toronto's Patricia Marsh got her start as an outcall dominatrix, working out of a single suitcase, a Toronto dominatrix would be hard-pressed to find clients that way these days. A fetish worker can still find outcall work in areas where there is no competition, but in cities where there are already established dungeons, it's nearly impossible to find clients who will agree to outcall.

Be careful in choosing your dungeon space. You'll want a space that's secure and private, but you also need to know that your landlord won't suddenly evict you should he or she discover what you're doing in that space. Some workers rent warehouse space. Be careful with that; you don't want to find yourself in danger because your location is too remote. I know of several fetish workers who work from one or more rooms of their home. This can be a satisfactory arrangement, especially if you have a dog, roommate or colleague living with you. Finally, some fetish workers rent apartments for the sole purpose of converting them into a working space. This works out fine so long as you have thick walls and accommodating neighbors. The dungeon space where I worked in Chicago was in a garden apartment with just such an arrangement.

You'll need a suitable wardrobe. In most cases, one outfit is enough to get started. If you can only afford one outfit to begin with, choose something in black. A corset is a wise investment. You can find an acceptable off-the-rack corset in most major cities for around $200. If you are plus-sized, check out your local transsexual shop (if you don't have the good fortune to live in a

larger city that's blessed with a trannie shop, you should be able to find one online) for something in your size. You'll want black spike-heeled shoes, preferably patent leather, and stockings.

The rest of your outfit depends on your personal style and the image you want to project. Whether you go with a spandex miniskirt or a long, sweeping black governess-style gown, remember to stay covered up. You can show off your cleavage, and you want to show off your figure but for the most part you want to be mysterious and veiled. The more you look like Bimbo Bunny, the less respect your powers of domination and skills of torture will receive. The professional submissive is, of course, an exception to this rule. The pro-sub should wear something skimpier to help announce the subservient role she plays in her profession.

A pro-sub would also do well to consider more sets of clothing. While a pro-domme can get away with wearing what she wants to wear by virtue of the power surrounding her role, a pro-sub will often be expected to have extra outfits to please the whims of her client. Some popular additions to the basic skimpy outfit include a cheerleader outfit, a Catholic school girl uniform (complete with white cotton panties), and a pink babydoll nightie or something similar. Thrift stores can be a good place to costume-shop. If you sew, you'll find patterns for many of these types of outfits in the catalogs at your favorite fabric store as well.

A professional fetish worker will also need equipment. You'll need to decide what sort of fetish worker you are and what your personal boundaries are before you start offering your services to clients. Your boundaries and skills will determine what you have in your dungeon. The most basic equipment should include ropes, some form of restraint furniture such as a spanking horse, floggers, blindfolds, nipple clamps, riding crops and canes. Someone who only offers basic domination won't last long in the business, though. You'll need a variety of skills and your dungeon will reflect that with a variety of equipment. A professional dungeon

might also have equipment for enemas, costumes and wigs for "sissy-fying" clients, electric toys such as violet wands or shockbox inserts, a playpen area with oversized baby clothes, diapers and toys for "mommy" sessions, play-piercing equipment, suspension equipment and more.

Okay, enough about the things you need. What about the real meat of the fetish worker: her skills? How do you learn to be a dominatrix or a professional submissive? The best fetish workers started out as fetish lovers. Just as a prostitute who hates sex will quickly seek the refuge of an office job, a fetish worker who does not love BDSM will not last long in the profession. The more you love what you are doing, the better you will be at it.

So the best advice about how to learn the business is to start out learning the pleasure. Depending on how deep your interest is and how much you have already explored, your fetish worker training might take a short amount of time or it might take you years to be ready to work. Here are some good ideas to start your education.

Study BDSM as if it were a school subject. Read books about it (I suggest many of the other fine books from Greenery Press, especially *SM 101: A Realistic Introduction* by Jay Wiseman), watch some of the higher quality SM porn films (Kym Wilde is one of my favorites), and study BDSM web sites. Learn the terminology, the various popular fetishes, the expectations and the rules of the scene.

Look to see if there is a local fetish club near you. Join and watch what others do, talk to a lot of people, try your hand in a "civilian" setting, attend workshops, etc. Yes, the people in the club will know where you learned and how long you've been into the scene, but the bulk of your clientele will generally not come from that scene. That's not to say that you should lie to clients about your experience: an experienced client will see right through you if you claim to know more than you really do. But the odds

are against potential clients being present when you take your first fumbling steps into the world of BDSM.

You might consider paying a professional dominatrix to give you lessons. Not all fetish workers are good teachers, and some of them may be unwilling to part with their hard-won secrets, but some fetish workers welcome the opportunity to teach more about their arts. Cleo Dubois in California is one such fetish worker. She actively advertises her Academy of SM Arts. This can be an expensive way to learn new skills, but your chances of picking up the specific information you require are higher when you seek a professional. One of the best uses of this mode of education is to acquire a specific, specialized skill such as play-piercing or mummification.

Finally, when you feel ready to take the plunge, you may want to ease into the work with some on-the-job training at someone else's dungeon. Some dungeons employ multiple fetish workers and may be willing to take on a new dominatrix or professional submissive on a trial basis. This is a wonderful place to learn the ropes because you'll get a chance to watch other fetish workers in action. Some dungeons have a sense of camaraderie, while others are highly competitive. If you are forced to have sexual contact with clients or other workers or if you feel exploited in any other way, you should leave as soon as possible. If you're fortunate, you'll have chosen a dungeon with a close atmosphere where you may form friendships and business partnerships that last for years.

Because fetish work is legal in most places (so long as it does not involve sexual contact) the prices don't vary as wildly as escort prices. The average price to expect is between $150 and $400 per hour. Before you start counting your millions, though, you should be aware that fetish workers typically have fewer clients on the average than escorts. So don't expect to earn $10,000 a week unless you're amazingly skilled, experienced and world-renowned with a priceless amount of dungeon gear and a huge,

devoted client base. Even then, don't count on becoming rich overnight. It takes time to build up your business and unreasonable expectations will just make you bitter.

Many fetish workers I've talked to have started as escorts and switched to fetish work after collecting enough gear and experience. For most of them, the switch didn't take place overnight. Most of my colleagues who followed that route had to continue to work as an escort at night while struggling to get their fetish work off the ground during the day. Happily, it can be done. It's not uncommon for escorts and strippers to switch to domination as they age. What's considered old for a stripper or escort is often considered young for a dominatrix. Many women continue working as a professional dominatrix long after they have gone gray and begun to develop wrinkles on their faces.

Good luck in your quest. If you haven't played BDSM games before, you may find yourself with a new obsession. Fetish work is a very exciting area of sex work. I've loved every minute of my fetish work and I hope that you find the same joy if you choose to seek it.

For More Info

Yahoo: Professional Dominatrices
http://dir.yahoo.com/Business_and_Economy/Shopping_and_Services/Sex/BDSM/Professional_Dominatrices/
A good place to find fetish work directories where you can list your services as well as home pages of professional fetish workers.

Yahoo: BDSM
http://dir.yahoo.com/Society_and_Culture/Sexuality/Activities_and_Practices/BDSM/
More links to sites about the BDSM culture than you could ever hope to read in one lifetime.

Phone Sex

There are many reasons why some clients prefer phone sex over physical contact. For some, phone sex does not feel like cheating on their spouse. For others, phone sex does not carry the risk of disease. Some people enjoy the mystique of talking to an unseen person.

The most important qualities a phone sex worker needs to possess are an interesting and emotive voice, a vivid sexual imagination and an ability to quickly discern what others are looking for. In most phone sex work, the longer you are able to keep a client on the phone, the higher your earnings will be.

Not all phone sex is straight "vanilla sex" – the standard boy-meets-girl, oral and intercourse that mainstream society thinks of as normal. For every fetish you can imagine, there is at least one phone sex line – often dozens.

Phone sex can be a safe way to sample the sex industry to see how you feel about the work. Because you're just a voice on the end of a phone line, you don't have to worry about disease or violence. Phone sex gives you a chance to relax and see how you feel about the core of sex work – using your abilities to turn people on and helping strangers have orgasms.

Phone sex can also be a good place to temporarily retreat if you're feeling burned-out by sex work that involves a higher degree of physical contact. You can retire into phone sex or use it as a working vacation while you recharge your batteries.

Phone sex also offers a clever way to supplement your income as a porn model or feature dancer. Your fans will often be willing to pay by the minute to talk to you. Working the phones for a few hours a day will increase your popularity as well as your bank balance.

I stumbled across phone sex accidentally one evening when I was bored. I was flipping through the pages of an adult magazine when I saw an ad for phone sex. "Women call free!" the ad said. I dialed the toll-free number and whiled away the evening teasing strange men who had paid for the privilege to talk to us women who dialed in for free.

After a few evenings of that, I realized that I could be getting paid for what I had been giving away. I flipped through the same adult magazine until I found an ad for phone sex that said, "now hiring." I called for a job and that's when I found out that phone sex for pay was a bit different from phone sex to alleviate boredom.

The first thing I noticed was that I went from hanging on the phone all evening to waiting all evening for the phone to ring. There were nights when the phone would ring and ring, but there were also plenty of nights when I napped or read for hours between calls.

When you work a phone sex job from home, you get paid for the amount of time you spend on the phone. Because the calls are variable, expect your income to be variable too. There are lean weeks and stout weeks, but only you can decide if your weeks balance out to an acceptable income. Phone sex pays roughly between fifty cents and five dollars per minute, depending on who you sign up with. The average call is between five and ten minutes.

While it's far more common to do phone sex work from home, there are some companies that hire phone workers to sit in an office. These companies vary greatly in how they pay: some will

pay an hourly wage with commissions while others only pay for time spent on the phone, just like at home. If you decide to work in an office, make sure you know exactly how you'll be paid before you accept the job.

The easiest way to find a phone sex job is to flip through the ads in the back of adult magazines. Check both local and national magazines as some companies hire women all over the country to work at home. You'll also find plenty of phone sex services advertised on the web, many of whom are hiring.

One thing you want to watch out for is the phone sex companies that require you to get an AOL account and troll chatrooms for clients. Not only is this illegal, it's annoying to both the people who visit the chatrooms and the would-be phone sex worker who has to constantly advertise a service and then give up a percentage of her earnings. A reputable phone sex company will take care of advertising for you.

If you enjoy advertising, you may want to consider going into business for yourself. You can go through a company like keen.com that manages the phone-tag game for you. Or, if you're serious and have money to invest, you can get your own 900 number. Going into business for yourself carries certain risks, but the rewards can be immense.

If you work for someone else, what will your working day be like? You'll probably start the day by calling your agency to check in. Even if you have a set schedule, most companies want you to call them so they don't have to deal with phone juggling at the last minute. Once you've called to say that you're "on the clock," you'll have to leave your phone line open for the duration of your shift. Some workers have two phone lines so that they can use the phone during their work hours, but most I've known just work off their regular home line.

When someone calls the phone sex line, they'll either talk to an operator about what sort of girl they want to talk to or the

system will ring them straight through to you. If you are working a 900 number line, your job at that point is to keep the caller on the phone as long as you can. If you are working a phone line that only accepts payment by credit card, you may be required to take the caller's credit card information and phone number and call him back after verifying the payment. With credit card calls, there is usually a set time limit so you just talk to the client as long as he wants to (within the set limit) and then ask him if he wants to re-negotiate or say goodbye.

What do you say to keep a caller on the phone? One of the best methods of knowing what to say is knowing how to listen. Most callers with an unusual fantasy will tell you what they want. Your job then is to narrate it back to him in a sexy manner. For example, if a caller started in by calling you "mommy," you might want to respond by asking him if he's been a good boy. Phone sex is a give-and-take — interact with your callers and try to get inside their fantasies.

Expect to be called with every fantasy you've ever heard of and many you haven't. Phone sex can give you great experience and insight into the diversity of human sexual responses! Expect to be shocked at some point, no matter how unshockable you think you are. Expect to encounter at least one caller that you just can't handle for whatever reason. But also expect to have fun. I think you'll get a real kick out of talking dirty to strangers. I think it's a blast!

For More Info

Phone Sex FAQ
http://www.sexuality.org/l/workers/phonesex.html
Although written from the client's point of view, there is some good, juicy information here.

Yahoo Phone Sex Services Listings

*http://dir.yahoo.com/Business_and_Economy/Shopping_and_
Services/Sex/Adult_Services/Phone_Services*

More phone sex services than you can shake a stick at! Wade in, surf around, see who's hiring.

Yahoo Business Opportunities: 1-900 Numbers

*http://dir.yahoo.com/Business_and_Economy/Business_to_Bus-
iness/Business_Opportunities/Telecommunications/1_900_Numbers/*

If you want to go into business for yourself, you'll need a 900 number. Here is a listing of some places to obtain one.

Keen.com

http://www.keen.com/

This thriving "live answer" site allows people to connect over the telephone. The site allows adult listings and serves as an operator, connecting callers without revealing their phone numbers to each other. You can offer recorded messages or set up hourly schedules for answering your phone. Keen pays you half the income on recorded messages and 70% of the income on live conversation.

The Phone Sex Yellow Pages

http://www.phonesexyellowpages.com/

Listings for various phone sex services. This site includes a link to information about applying for a position with the listed companies.

82
◆ ◆ ◆ ◆ ◆ ◆
phone sex

SAFER SEX

S afer sex is at the same time one of the most boring topics and
one of the most important. Yes, I'll admit it's boring. Of course,
for excitement and drama, you could try a terminal illness... no,
on second thought, maybe boring is a good thing.

Then again, safer sex doesn't have to be entirely boring. I have
a touch of a "doctor fetish," and some of my fantasies are not
complete without latex gloves. I figured if I could get excited
about latex gloves which are basically, in a sexual context anyway,
just a tool for safer sex, then I could find a way to get excited
about the rest of the tools and procedures of safer sex as well.

Before I go any further, I suppose I should explain why I'm
calling it "safer sex" instead of "safe sex." Most people already
know the answer to that, but for those of you who don't, any
sexual activity presents some amount of risk. The only 100% safe
form of sex – the form of sex that promises absolutely no risk of
pregnancy or disease – is non-contact sex. Masturbation and fan-
tasy, phone sex, self-masturbation while looking at one another
through a pane of glass: these are the kinds of activities that could
be called "safe sex." Any sexual activity involving contact is safer
or riskier, but never 100% safe.

Safer sex is a very important topic for sex workers who have
physical contact with our clients because many of us literally put
our lives on the line. Of course safer sex is a very important topic

for sex workers who don't have physical contact with their clients as well – information not used at work will still come in handy at home.

We protect ourselves as best as we can, but we would be fooling ourselves if we thought there were no risk involved. Safer sex is important because it turns risky behavior into a calculated risk. The more we study safer sex and religiously practice what we have learned, the lower our chances are of contracting a disease.

I can't make any promises – there are no guarantees. But I can say that I have always felt confident that I have done everything possible to protect my health. Over the course of my career, I've had sex with well over a thousand people – closer to two thousand, actually – and I have never contracted any kind of sexually transmitted disease at work. I've used thousands of condoms over the course of my life and I've only had one condom break (with my first boyfriend, before I knew about proper lubrication).

Like I said, I can't make any promises. Sometimes condoms break – but it's rare. And sometimes people contract diseases despite taking all the proper precautions – but it's rare. If you want official numbers and statistics, read some condom inserts and surf the Centers for Disease Control website for more details.

Before I go into the fun side of safer sex, let's spend some time talking about disease – the reason why we're planning to develop a latex fetish. I shouldn't have to talk about this at all. Anyone who has sex should already know these things. But just to make sure we're all on the same page here, I'll go over them briefly.

You can find photos of different stages of most of these diseases online or at your local public health clinic. I strongly recommend getting some photos and studying them, disgusting though they can be, so that you have a good idea of what you're looking for.

Critters - Crabs, Lice and Scabies

What are they?

Critters are generally more of an annoyance than anything else, but they're unpleasant and most people do not consider them a welcome gift. They can also be a pain in the ass to get rid of.

Crabs are pubic lice. There are also head lice that hang out only on the head and neck hairs. Pubic lice are easier to spot because you have a natural excuse for getting close to your client's genitals and playing with his pubic hair. Head lice are harder to spot but not impossible. I once spotted head lice on a client with dreadlocks because there were louse eggs all over his dreads. He was horrified (he somehow hadn't noticed or had assumed the whitish-grey specks and itching were dandruff). He did battle with the lice for a while before he resorted to cutting off his hair to get rid of them!

That was an extreme case, though. Most people don't like to have bugs so you're more likely to spot someone early in an infestation if you ever see critters at all. In the case of scabies, you won't see the critters (they're too tiny) but you will see the evidence they leave behind them.

How do you spot them?

Scabies are fairly easy to spot if you know what you're looking for. They leave a little line of red bumps, all in a row. You'll be most likely to spot their trails in the genitals, the armpits, the webbing between fingers and toes. Don't touch! You can catch scabies from skin contact or secondary contact such as sharing towels.

Head lice don't wander far from their chosen habitat – the human head – so you would have to look into someone's head to spot them. They can hang out for a while on pillows and such, and for much longer in combs and brushes, so don't assume you're safe if you haven't had direct head-to-head contact. The problem

is, head lice are very hard to spot and there's really no way to look for them without your client figuring out. Basically, you're out of luck when it comes to preventive measures against head lice. The bright side to head lice is that you probably won't catch them. Head lice are far more common among U.S. children than adults.

Pubic lice are much easier to spot than head lice. Pubic hair is shorter, you've got a good excuse to go rummaging around in it, and pubic lice tend to jump around when disturbed. Run your fingernails lightly through his pubic hair and watch to see if any tiny critters go hopping around at the disturbance. If you see hopping critters, get rid of the client! A condom might protect you from syphilis, but it will never protect you from crabs.

What should you do if you get them?

There's usually no need to go to the doctor if you get critters. You can buy a variety of creams and shampoos over the counter at the drugstore. Be sure to follow the instructions on the package precisely. Treatment times or repeat treatments are based on the life cycle of the insect you are trying to get rid of. If you neglect a follow-up treatment or don't administer the treatment properly, you may leave eggs behind that will hatch into a whole new generation of adult critters to plague you with itches, unsightly bumps and a general drop in popularity.

Some critters are resistant to the over-the-counter stuff. If you follow the directions properly and still find uninvited visitors, see a doctor.

Syphilis

What is it?

Syphilis is a sexually transmitted bacterial infection that can lead to insanity and death if it goes untreated. It killed Al Capone and it can kill you if you don't get rid of it. Fortunately, it takes about 20 years for syphilis to kill a person, and it's ordinarily

quite curable, so you don't need to start making out your will if the doctor tells you that you've caught syphilis.

Syphilis can be contracted from contact with sexual fluids and sometimes from skin-to-skin contact. Fortunately, there are treatments for it. Unfortunately, some states have laws about reporting syphilis, so it's one of the things with a potential to put you "on the radar" when it comes to law enforcement and illegal activities. Don't let that frighten you out of getting treatment, though!

How do you spot it?

Syphilis manifests in stages. In the first stage, the infected person gets one or more red ulcers. This ulcer is most frequently on the genitals but it occurs wherever sexual contact took place – so it could also be somewhere on or in the ass, in the mouth or on the balls. The ulcers aren't painful. Sometimes it takes weeks for an ulcer to show up.

The symptom of the second stage of syphilis is a rash on the palms of the hands and the soles of the feet.

The third stage includes symptoms such as heart disease, eye problems, massive neurological damage, dementia and death.

As you might have already guessed from the descriptions, a person with syphilis doesn't always look ill, even when they're contagious. Your best defense against syphilis is to practice safer sex and refuse to engage in intercourse with anyone who has red sores or streaks of red discharge in their underwear. If possible, you should also wash your client's skin before intercourse and your own skin afterwards with antibacterial soap and water. Finally, watch for signs of syphilis in yourself and get tested regularly so that you can get proper treatment should you catch the disease.

What should you do if you catch it?

Go immediately to the doctor! You may be required to supply the names of the people you have had sex with recently. You might

find yourself in an uncomfortable situation if you can't give the doctor any names. Decide for yourself how you're going to deal with the situation, but whatever you do, don't consider doing nothing to be a valid option. Syphilis is a serious disease and you must get treated if you should happen to catch it.

Gonorrhea

What is it?

Gonorrhea is a sexually transmitted bacterial infection that is much more common than syphilis. It appears to be more prevalent in some geographic regions than others. For example, my doctor tells me that gonorrhea is pretty rare in Idaho where I currently live, and practically non-existent in Canada, but pretty common in the Southern states.

Like syphilis, it can infect your genitals, your anus or your throat. Gonorrhea is treatable but in some places it is mutating. Strains of gonorrhea that do not respond to antibiotics have been reported in parts of Mexico and in San Diego, California. Protect yourself!

How do you spot it?

Some people can have gonorrhea and exhibit no symptoms at all. The classic symptom is a burning sensation when urinating, but that's not a foolproof indicator. Many people can have contagious gonorrhea with no burning sensations at all, while others experience excruciating pain with gonorrhea.

Sometimes a man with gonorrhea will have a greenish discharge from his urethra. This is the only symptom you can effectively check for. Look for a green-yellow discharge when you "milk" his penis and green-yellow stains in his underwear. If you see any signs of suspicious discharges, send the client away – he's not worth the risk. (Don't forget to wash your hands!)

What should you do if you catch it?

Go to the doctor. If you're like most women you won't need any convincing, as women experience pain from gonorrhea more frequently than men do. More likely you'll be quite eager to go get some antibiotics! Again, you may end up dealing with doctors who want to know who you've had sex with, but people who have been treated for gonorrhea tell me that they're often just told to tell their sex partners or sometimes given clinic cards that they can give to their partners. Left untreated, gonorrhea can cause pelvic inflammatory disease which can lead to tubal pregnancies and sterility, so get treated promptly.

Herpes

What is it?

Herpes is a virus infection that is spread by physical contact. There is no cure for herpes. There are some drugs that will help lessen or eliminate periodic outbreaks, but the herpes virus stays in your body forever and you may be contagious at any time, even when you're not broken out (though an infected person is much more contagious during an outbreak). I personally know a person who caught herpes from his lover when she was not broken out. It can happen!

How do you spot it?

Herpes outbreaks manifest as clusters of sores in the area of infection. They can appear in your mouth, on your genitals or in your ass. The virus can be spread around on fingers and on toys like dildos. The herpes virus can end up in places that had no primary contact that way.

Look for clusters of pink sores on the head of his cock, on his balls, on his thighs or around his anus. The sores may be opened from scratching or they may be crusted over with dried fluids. If

you spot anything that looks like this, send him away! You can catch herpes even if you're using a condom, because the virus may be on parts of the body that a condom doesn't cover. Don't forget to wash your hands thoroughly as well.

What should you do if you catch it?

You should go to a doctor if you suspect you've got herpes. You'll need to be checked for other diseases and the doctor may prescribe some medicine to ease the discomfort of the sores. If the doctor verifies that you do indeed have herpes, you will have to think carefully about ever again having unprotected sex, even with a primary monogamous partner (unless that partner also has herpes). Your doctor, or a herpes support group, can help with the information you need to make a realistic decision.

Chlamydia

What is it?

Chlamydia is the most common bacterially transmitted STD in the U.S. It can affect the penis, vagina, cervix, anus, urethra, or eye.

How do you spot it?

Chlamydia very often has no symptoms at all. In women, it may cause bleeding between periods, bleeding after intercourse, abdominal pain or painful intercourse, a mild fever, urinary pain or frequency, or an inflammation or yellowish discharge of your cervix. In men, the symptoms are similar to those of gonorrhea – a milky or watery discharge from the penis, pain on urination, and tender or swollen testicles.

What should you do if you catch it?

See a doctor immediately. Left untreated, it can cause pelvic inflammatory disease, which can make you infertile and cause

dangerous tubal pregnancies. In men, it can also cause sterility, and some rarer but disabling problems such as arthritis. Fortunately, chlamydia is easily treated with antibiotics.

Genital Warts

What is it?

Genital warts are warts caused by a virus (actually a bunch of different viruses). They are primarily found on the genitals and in the ass, but they can be spread to any part of your body through skin contact. The Human Papilloma Virus (HPV) doesn't always cause visible warts so you can catch it without realizing that you have it. Moreover, since a woman tends to get HPV internally, you may never see the warts. You should get checked for HPV infection regularly because there is a strong link between HPV and cervical and anal cancer.

How do you spot it?

Like I said, sometimes you can't see it at all, but what you should look for is little growths, either lighter or darker than the surrounding skin, that tend to show up in clusters. Look around his cock, balls and thighs for the warts which can look like anything from dark blemishes to tiny cauliflowers. You may also feel little hard spots with your fingers that aren't visible to your eye. If you spot what you suspect are genital warts, don't have sex with him. If there are warts where a condom doesn't cover them, you can catch them even if you're using a condom.

What should you do if you get it?

Go to the doctor. Don't try to use Compound W on genital warts – you could really hurt yourself and still have warts when you're done. The doctor will give you a cream or a shot, or you might need a minor surgical procedure such as cryosurgery to remove the warts.

Hepatitis

What is it?

Hepatitis is a virus and it can kill you. There are several types of hepatitis virus, which is why you hear about Hepatitis A, B, C, D, E and so on. Anything past Hep C is very rare – if you catch Hepatitis it will most likely be A, B or C.

Hepatitis A is usually caught from contact with feces. Sometimes you'll hear about a hepatitis epidemic in a city that is usually traced to something like a restaurant using lettuce that was grown in infected fertilizer. Hepatitis A can make you very sick, but it usually runs its course and goes away. As a sex worker who engages in physical contact, you'd only be likely to get Hepatitis A if you were rimming a client (licking his asshole) who was currently contagious.

Hepatitis B is transmitted through bodily fluids like semen and blood, and Hepatitis C is transmitted primarily through blood. These are more dangerous strains of hepatitis. They can damage your liver and they can stay with you for life.

How do you spot it?

A person with contagious hepatitis can look perfectly normal. You might see a yellowing of the eyes if they are experiencing liver damage, but that's only after they become very sick. Since safer sex practices will generally protect you from hepatitis, it's best to just assume that everyone has it and always take precautions.

What should you do if you get it?

There are some treatments for Hepatitis B and C but they are limited. You should be vaccinated against Hepatitis A and B (but don't use the vaccination as an excuse for unsafe sex). Your best offense is a good defense – get the vaccinations now, protect yourself during sex, and don't inject drugs.

Molluscum Contagiosum

What is it?

Molluscum Contagiosum (MC) is a viral infection. Although it's most often sexually transmitted among adults, it can be trasmitted through skin-to-skin contact as well.

How do you spot it?

MC causes pimples with dimples in the center. They grow larger until they're the size of a pea or a pencil eraser. The sores tend to show up in clusters and can be found anywhere on the body, most often in the genital area. There's a thick white slime-sludge inside the sores.

Don't ignore MC in a client! You can catch it even if you practice safer sex. It's far better to send him away.

What should you do if you get it?

Go to the doctor. It will eventually go away on its own (unless your immune system is suppressed), but you shouldn't just sit around and wait for that to happen, especially since it can take years in some people and may cause scarring. The doctor can prescribe medication or can freeze the pimples off. When you go to the doctor, ask to be checked for other diseases at the same time.

Bacterial Vaginosis

What is it?

Vaginosis is an imbalance of the bacteria normally found in your vagina. One reason you were taught to wipe from front to back is that bacteria from your colon can lead to vaginosis.

How do you spot it?

There are some forms of bacteria that lead to vaginosis that a

man can give you but you'll never spot them. Just watch yourself. If you develop a discharge or a strong fishy smell, you may have vaginosis.

What should you do if you get it?

Go to the doctor. Vaginosis is easy to treat. The doctor will probably want to test you for other STDs. It's never a bad idea – go for it.

HIV/AIDS

What is it?

It's one of the scariest viral infections out there. It's also one of the most fragile viruses – outside the human body, HIV can be killed with soap and water. Inside the human body, you carry it forever. HIV is spread through bodily fluids, mainly blood and semen.

How do you spot it?

Someone with HIV looks totally normal. You can't spot it. Like hepatitis, just pretend that everyone has it and always use safer sex methods. Last I heard, heterosexual women were, as a group, among the fastest growing HIV demographics. In other words, straight chicks are very susceptible to HIV and shouldn't assume that they're immune because they aren't gay men. AIDS is no longer "just a gay disease."

What should you do if you get it?

You should have your blood tested at least twice a year for HIV. In the Nevada brothels they will check your blood monthly. If you test positive for HIV, you should go immediately to the doctor, as there are drugs that can extend the amount of time you stay healthy. HIV doesn't have to be a death sentence. I have known men who have been HIV-positive for 20 years and haven't

gotten sick yet. Healthy living and positive thinking have a lot to do with survival.

If you test positive for HIV you should consider retiring from sex work involving physical contact. You and I both know that safer sex will protect others from catching HIV from you, but the law is very nervous about HIV and you may find yourself on trial for attempted murder if you are discovered to be working with the knowledge that you are HIV positive.

Many forms of sex work will be closed to you if you are found to be HIV positive. The Nevada brothels will not hire you and the porn industry will reject you as well, with one exception. Some HIV positive porn actresses have continued by starring in bukkake films. Bukkake is a no-contact form of the more traditional gangbang film. In bukkake, a woman holds a bowl under her chin while scores of men ejaculate on her face. Because the woman does not touch the men, it doesn't matter to the film cast and crew whether she's HIV positive or not.

Whew! I think one reason I find going through all those diseases so boring is to cover up my underlying fear. Safer sex protects you from a lot of things, but not everything. There are diseases that can stay with you forever and diseases that can kill you. There are so many symptoms to look for when you're inspecting a client and so many diseases that don't have visible symptoms. It's enough to scare a girl into a nice quiet office job!

But remember when I said that I've never caught a disease on the job? I wasn't lying to you. Safer sex may not protect you from everything out there but it sure puts the odds in your favor. Sex work that involves physical contact with clients has a certain measure of risk. It wouldn't be right for me to try to pretend that risk doesn't exist. But with education and awareness, it can be a calculated risk.

You may decide that the risk is too great and that is fine. There is no shame in deciding that the life of a sex worker – or of

some types of sex work – is not for you. Or you may decide that the rewards are worth the risks and that's fine, too. That was obviously my decision and I haven't regretted choosing sex work.

One reason I've skipped around among the different fields of sex work is to taste a variety of working conditions, but that's not the only reason. Each field of sex work has its own stresses and rewards. When I've gotten too stressed out by one field of sex work, I've often switched to a different form of sex work for a while.

Obviously phone sex operators don't have to worry about all these diseases! Neither do live girl show workers or strippers. If you find that prostitution makes you too nervous because of the possibility of contracting diseases, it doesn't necessarily mean you aren't cut out for sex work altogether.

Now then, about that latex. Your client probably hates it (although I've known some absolutely charming clients who would be horrified if they were offered unprotected sex) and you may hate it as well. It deadens sensations, it's clumsy, it smells and tastes funny, it gets in the way. How can you possibly learn to enjoy it?

For starters, you need to stop thinking of it in those terms. Reprogram your brain. Every time you catch yourself thinking something negative about safer sex practices, force yourself to balance it out by thinking something positive instead. This may be difficult at first, but it will gradually become second nature.

Think of latex as a game. Think of condoms and gloves and such as sex toys. Think of them as naughty. I like gloves because they make me feel like I'm part of a subversive sexual counterculture. Comb your mind for thoughts and images until you have an arsenal of arousal associated with safer sex tools. The better you can feel about condoms, the better you will be able to help your client enjoy sex with a condom.

You may as well splurge on quality condoms. Any condom on the U.S. market has passed the government tests. Experiment

with condoms until you find some that please you. My favorite condom is thin enough to let some heat and sensation pass through and it has a baggy head so that the latex slips around on my partner's cock head but stays firm and in place along his shaft. My favorite lubricant is silicon-based, safe for use with latex, extremely slippery, concentrated so three drops is plenty, has no smell or taste and feels really good against my skin.

Visit your local adult toystores. Many of them will offer variety packs of condoms and lubricant so you can try different ones out to see what you like. Having a variety of safer sex toys to play with can make condoms more festive and experimental. Finding a condom or lubricant that you absolutely love can help you learn to appreciate safer sex more.

Don't just shop – use those condoms! Use them for penetration and for blow jobs, too. Remember all those nasties you can catch from unprotected oral sex? Use condoms. There are some tasty mint-flavored and bubble-gum flavored condoms you can use. I've found regular unlubricated condoms are just fine, too. There's an art to giving a satisfying blow job with a condom. Practice whenever you get the chance. There are ways to use the latex to your advantage, such as using pressure from your mouth to make the latex vibrate as you take his penis in and out of your mouth. You probably won't want to try deep-throating him, though! Rubber-throat is not much fun.

A final few words about condoms and lubricant. Never use more than one condom at once. It's not doubly safe, it's doubly dangerous. The friction between the two condoms makes it more likely that either or both will break. You would also be wise to avoid condoms or lubricant with nonoxynol-9 on or in them. After various studies, the Centers for Disease Control have stated that nonoxynol-9 can cause micro-lesions in the skin, thus *increasing* your chances of contracting a disease! I have a bad reaction to nonoxynol-9. My skin swells up and begins to burn and itch. I steer clear of it for that reason. If you have a negative reaction to

nonoxynol-9, don't keep using it out of fear. If you don't have a
reaction to nonoxynol-9, go to the Centers for Disease Control
site and read the studies – decide for yourself.

You should protect yourself when he performs oral sex on you
as well. Some clients want to eat your pussy because they want to
get you off and others want to taste your pussy. The former may
appreciate a safer sex barrier while the latter will definitely hate
it. It's very important to protect yourself, though. Your client may
claim to be healthy and may scoff at your caution, but there are
several diseases you can catch from letting him lick your bare
pussy. And even if your partner is disease-free, allowing some-
one who's been drinking beer to lick your bare pussy can lead to
a terrible yeast infection.

The risk of infection goes both ways – one of my colleagues
had a bladder infection but didn't realize it. Another colleague
licked her bare pussy and got a horrible throat infection! She
was incredibly ill from it – said that it was worse than the worst
strep throat she'd ever had. Protect yourself, protect your client,
use a barrier.

My favorite barrier for pussy eating is plain old plastic food
wrap. Saran makes plastic food wrap in pretty colors. It costs
more, but I like the pink and purple plastic wrap. The pretty col-
ors add a festive touch to an act that feels awfully silly the first
time you try it. You'll probably want to keep clear wrap on hand,
too, for people who want to see your natural colors.

Put a little lubrication on your pussy and tear off a large sheet
of plastic wrap. You can either wrap it around once, hold the
bottom by lying on it and hold the top with your hand... or you
can make "plastic wrap panties" out of it by wrapping it over your
crotch and then around your waist once or twice to hold it in
place. Plastic wrap has been approved as a safer sex barrier by the
Centers for Disease Control, so wrap yourself up and enjoy the
peace of mind that comes with protected orgasms.

Many clients choose hand jobs because they want skin-skin contact. If you want to be perfectly safe, always use gloves for a hand job. I'll confess here, though, that I never did. I always gave bare-handed hand jobs and washed my hands thoroughly afterwards. I never gave a hand job if I had cuts or sores or hangnails on my hands because of the increased risk. You may decide to use gloves, though, and if you're sexy about it you can talk clients into accepting it.

Gloves also come in handy if you're unsure about a client's disease status but you want to serve him anyway. With gloves, you can give a man a hand job even if he appears to have herpes or some other illness. Put two gloves on. Don't touch anything else once you've touched him, including your lubricant bottle! Give him a hand job in such a manner that his semen doesn't splash all over the place – catch it entirely in your gloved hand if you can.

When you're done, clean your client up with paper towels then pull the gloves off inside out as you take them off, put one inside the other and throw them away immediately. Wash your hands thoroughly even though they've been inside gloves. It's up to you whether you play with a client with sores at all. Never feel bad about sending a client away. Your health is precious.

How can you inspect for disease without making your client feel like he's at the clinic? Here's a description of a D.C. or "dick check" as it's performed in a brothel. You'll be inspecting his penis for any sort of visible signs of disease or infestation, but try to make it feel as non-clinical as you possibly can. My favorite lines were, "now it's time to play doctor," or "let me see what I'm going to get now," either said in an eager tone of voice with a naughty gleam in your eye.

Have your gentleman unzip his trousers and pull them down. You want to look at his penis and scrotum thoroughly, checking for sores, warts, ulcers, etc. If in doubt about anything you see on his genitals, strongly consider refunding your gentleman's

money and sending him on his way. But above all, you must never tell him what disease you think he might have. Diagnosing a disease is considered to be practicing medicine. Just tell him that you're not sure everything's okay and that he probably ought to see a doctor.

If he has no visible lesions, put your hand around the base of his penis and "milk" it like a cow's udder. If you do it right, one drop of fluid should come out of his urethra. Have a good look at it – it should be clear. If it's cloudy or discolored, it could be a bad sign and you might want to strongly consider sending him away. Finally, run your fingernails lightly through his pubic hair and watch to see if any tiny critters go hopping around at the disturbance. If you see any, get rid of him!

Now, if he looks clean, move on to the wash – but never forget that looks can be deceptive. A person can have a sexually transmitted disease but look perfectly healthy. The best way to go about sex with multiple partners, in my opinion, is to treat everyone as if they were contagious. That way, practicing safer sex becomes an integral part of your sexuality, not some extra thing tacked on sometimes and forgotten other times.

If you're working in a brothel, you might wash your client during the inspection or you might do so after you've turned in the money. The house you choose will tell you their procedure. Most houses will provide a washbowl, usually plastic, in each room. If the house where you've chosen to work does not provide them, request one. You'll also need a washcloth, so if you're carefully doled out one washcloth per client, you'll have to go up to the window now to turn in your money and get some fresh linens.

If you're not working in a brothel, chances are you're in a hotel room where you'll find all the amenities. Some men object to being washed because they don't like the insinuation that they're dirty. Others will enjoy it as an exotic service if your attitude is

sexy. Getting a client to go along with safer sex procedures is 90% attitude, so work on developing a sexy bedside manner and you'll have a minimum of problems.

For More Info

Centers for Disease Control
http://www.cdc.gov/

The central clearing-house for new information about infectious diseases. "Health Topics A to Z" includes sections on HIV/AIDS and sexually transmitted diseases. There is also a search function on the main page.

AIM Healthcare Foundation
http://aim-med.org/

The Adult Industry Medical Healthcare Foundation. A non-profit corporation created to care for the physical and emotional needs of sex workers and the people who work in the Adult Entertainment Industry.

SaferSex.Org
http://www.safersex.org/

The web's oldest safer sex website.

San Francisco Sex Information
http://www.sfsi.org/

The website for a Bay Area sex information line.

Q&A About Male Latex Condoms
http://www.neahin.org/condoms/index.html

A NEA pamphlet about condoms and STD/HIV transmission

Planned Parenthood
http://www.plannedparenthood.org/

While Planned Parenthood mainly has a reputation for educating teenagers, this site has valuable information for everyone.

Thrive Online: Sexually Transmitted Diseases
http://www.thriveonline.com/health/std/std.index.html
An excellent collection of STD information.

Safer Sex Work

D iseases aren't the only thing you'll needto protect yourself against. Violence is a very real concern in many fields of sex work. Sex workers often have to make themselves vulnerable in the process of working. How can you hope to protect yourself?

For starters, you can never know too much about self-defense. Check your local college or community college for basic women's self-defense classes – often they're free or very inexpensive. You may also want to study some form of martial art in order to en-hance your self-confidence and ability to protect yourself from violence. There are many different forms of martial arts avail-able, so if one class isn't to your liking, try a different style to see if it fits your body and preferences better.

My favorite martial art is Aikido, closely followed by Bushido Judo. These are both "gentle" martial arts that teach the practi-tioner to use their opponent's height and weight against them. They are ideal for smaller, lighter people and ideal for those who want to be able to protect themselves with the least amount of force necessary. My Aikido sensei (teacher) showed us how each move could be used to just repel or pin an attacker and also how the same move could be used to break the bones of an attacker. I appreciated having the choice.

Check your Yellow Pages under "Martial Arts Instruction," make a few phone calls and attend a few demonstration classes before committing your time and money to a particular system.

But do consider getting some martial arts training. You may never need to use the things you learn in class but I can guarantee that you'll feel better knowing that you can protect yourself against the average, unarmed assailant. I've never had to openly battle with a client, but I've had a few pushy clients try to wrestle me. They didn't try for long!

Another important part of taking care of yourself is avoiding potentially dangerous situations. Train yourself to be aware of a way out of any situation. Sometimes being aware of something very small can make a big difference. For example, if you decide to get into someone's car, you should always check to see if the door latch is missing on your door. Learn to quickly scan a hotel room when you enter and if you're nervous about a situation and are checking out someone's room, don't forget to look in obvious hiding places. A colleague of mine got severely beaten by men who were hiding in the bathtub, behind the shower curtain.

You'll want to always be alert and aware, so avoid drinking or taking drugs while working. Sometimes you'll be dealing with dangerous situations. The last thing you want is impaired judgement! Even in fields of sex work that are legal and appear safe you'd do well to stay sober. What do you think will happen if you say the wrong thing to a police officer in a strip bar? What do you think will happen if you go to your room in a brothel with someone who is in a mood to play rough? Keep your faculties sharp!

Finally, consider letting someone know where you are when you're working. Just as hikers and cavers will leave notice of where they plan to be exploring, you should let someone know where you'll be. An escort agency phone worker, another sex worker, a lover, a parent, a friend – anyone who'll have some idea of what to do if you disappear.

I've been fortunate in my career – any mishaps have been relatively minor. Here's hoping that you are equally blessed.

Marking Your Services



Marketing Your Services

Once you've decided to be a sex worker you'll have to figure out how to find clients – you can't expect to get enough business from word-of-mouth referrals to keep you afloat. If you work on the streets or at rest stops, your location and your advertising are the same. Sex workers who do not streetwalk have to figure out some other way for potential clients to find them.

Adult Newspapers

Newspaper ads are a classic method of advertising. In some areas, Chicago for example, escorts can advertise in some of the non-adult papers. In most places, though, escorts, dominatrixes, private dancers, etc., will only be allowed to advertise in the adult newspapers. The easiest way to figure out if you'll be allowed to advertise in a publication is to see if they already publish similar ads.

There are a couple of important things to remember about advertising in non-adult newspapers and magazines. Many magazines will charge adult entertainers more to advertise with them than they charge other advertisers. Be sure to ask how much your ad will cost before you run it! For example, I only know of one paper in Boston that will allow adult entertainers to advertise and they charge $135 to $150 per week for advertising!

The other consideration is that some newspapers – most often the non-adult ones – will want to check your license before you run an ad. Depending on the town, they will either want to see your adult entertainer's license or your tax I.D. number. This isn't a problem if you have those things, but be forewarned that you may need them if you wish to advertise in certain publications.

Go to your local porn shops to find the adult papers. Some of these are free while you will have to pay for others. I'd advise sex workers not to advertise in swinger's forums, by the way. It's best to advertise in a manner and location where it should be obvious to those reading the ad that you are seeking clients, not lovers. I have tried advertising in a forum where people meet for sexual liaisons, figuring that my occupation would be apparent if I used phrases like "seeking generous gentlemen only." Whether people understand your ad or not, it leaves you wide open for the sort of person who wants to waste your time and then pretend they didn't know that you were offering a commercial service.

Reading other people's ads should give you a good idea of what to say in your ad. It can be intimidating to reduce your entire service to 20 words or less, but it's not as difficult as it might seem. It might be easiest to make a full list of everything you want to say and start crossing off the least important things and consolidating words where possible until you've reduced your ad to your required word count. Some things to consider listing are your working name, your contact info, some indication of what services you provide, a description of your appearance, a description of your personality and attitude, your rates.

You should avoiding mention of illegal activities in your ad, of course. Law enforcement officials periodically conduct stings based on adult ads. And don't think that you're getting off safe by using a euphemism like "greek" or "full service." These phrases don't fool anybody, least of all law enforcement, and can be used as evidence against you in court.

You may or may not wish to mention your rates in your ad. Print ads last a long time and you may decide to raise or lower your rates while the ad is still in print. On the other hand, if your rates are especially reasonable or especially high, you may want to mention them in your ad. Lower rates will encourage more potential clients to call you. Higher rates will discourage some people from calling and wasting your time.

Don't expect not to have your time wasted, though. Unless you specify hours when you will answer your phone, people will call you at all hours of the day and night once your ad is published. Expect a minimum of 20 calls for every one person who actually books time with you. Depending on a variety of factors, your query-to-booking ration may be much lower. Expect to hear recognizable voices after a while, as every town has at least one person who periodically calls all the escorts and asks them questions because he's bored and horny. The first time I took out a print ad in Chicago I got over 25 callers the first day (and no bookings!). The only reason I was able to answer that many calls was because the first question, "Do you do incall?" was usually all the caller needed to know before they moved on to the next ad.

For the first week my print ad came out, my phone was literally ringing constantly. The moment I'd set the receiver down, the phone would start ringing again. Expect this to happen. You should consider getting a second phone line if you can afford it so that you can keep your personal calls personal and your business calls business.

Third Party Management

Third party management makes advertising easy. In most cases, you don't have to worry about advertising at all! Just go in to the strip bar, brothel, girl show or escort agency and start working. This is one of the reasons why so many workers choose to

work for someone else despite having such a big percentage of their income taken by management.

Still, there are a few advertising options to consider even when working for someone else. One great idea is to have business cards printed. Some places already offer this service for their workers, but if you're at an establishment that doesn't, it's a simple matter to get some. Many print shops and office supply stores offer inexpensive business cards if you stick to their template. Include your working name, the name of the establishment where you work, and its address and/or phone number. If you keep a regular schedule, consider having that printed on the card. Otherwise, leave your schedule off the card and plan to write it on the back of several cards before you start your shift each night. If you have a website, include the site's address on your card as well.

Business cards are a good idea, no matter who you work for. It makes it easy for clients to find you again. Some streetworkers carry contact cards so their clients can find them again without driving the streets looking for them. Don't be surprised if some clients refuse to take your card. It's not a comment on the quality of your services; they may have a nosy wife at home!

A personal website is another option to consider even if you work for someone else. A website can draw more business to the establishment where you work and it helps potential clients to have an image of who you are and why they should make a special trip to the place where you work.

Online Marketing

Online marketing can seem quite complex to someone with little computer experience, but the Internet can be a real gold mine when it comes to marketing your sex work service. The independent escort and the fetish worker will reap the most benefit from marketing themselves online, but it's a good idea to

familiarize yourself with the Internet no matter what branch of sex work you choose.

E-mail: your online "phone number"

The first thing you should consider is getting an e-mail address. An e-mail address will allow potential clients to contact you for sessions.

One popular option is a free mail account with a Web provider such as Yahoo! or Hotmail. Free mail offers a couple of important benefits. It's free, so you're not in much danger of losing your e-mail address for non-payment and thus losing contact with established clients. Another benefit of Web-based free mail is that you can check your mail from any computer that has access to the Web. This can be a great advantage if you travel frequently.

Another option, also popular with those who travel, is an account with a national provider like AOL or Compuserve. These providers have phone numbers across the country so you can access your e-mail on a laptop computer for the cost of a local phone call no matter where you are. AOL offers another advantage for escorts: the personal profile. A profile is a collection of information about yourself that you can set while you're logged in. The profile is active even when you're not logged in and there are many potential clients who do profile searches, looking for words like "escort." Having a profile set up on AOL is like having a free advertising billboard included with your dial-up account.

It's important that you keep your language clean when you write your profile. Just having the word "escort" and the name of the city or cities and states where you work will be enough to get clients interested. You don't need to say things like "hot steamy sex." In fact, those sorts of comments are more likely to get your account cancelled! AOL is tough on adult content. Many other dial-up providers are tough on that sort of thing, too, so you should take care to check your user agreement and err on the side

of caution when letting people know you're available.

One thing you should check before you use an e-mail address from a dial-up account other than AOL is whether people can get your real name from your e-mail address. You may think this sounds very advanced and technical, but there are a great number of people who can use something called a "finger" to find out who you are. There are different ways to check finger information, but one of the easiest is to use a Web gateway. Go to *http:/ /www.grrltalk.net/cgi-bin/nph-finger.cgi* and enter your e-mail address. It may not be able to connect. This most likely means that your ISP has the finger port closed. On the other hand, it may return some information. I have run a finger on someone's e-mail address and gotten not only their real name but their home address and phone number as well! Make sure you know what your e-mail address says about you before you start using it for business.

If you have a DSL line or a static IP, you may feel that too much personal information is being revealed when you send e-mail. In that case, you might consider using Hushmail. Hushmail is a secure end-to-end, free, Web-based email service that provides a great deal of security and more anonymity than Hotmail or other free Web-based e-mail providers. Check out their Website at *http://www.hushmail.com* for more information.

Setting up a Web page

Now that you've got a way for clients to contact you, you want to think about putting together a website. You can pay someone to put together a site for you or you can learn how to build one yourself. I'd advise building it yourself if you have the time to spare. With a little reading and some trial-and-error you can probably put together a good site and save yourself a great deal of money. When you learn to create your own website, you won't be dependent on someone else every time you need to adjust your hours or add a new picture. If you have the money to spend and

just don't want to be bothered to mess with it, pay someone else to build a site for you. But either way, don't overlook the marketing value of a website.

You'll need someplace to put your webpage. The place where you put it is called the host. While it may be tempting to use free hosting like Geocities or the free Website that comes with an AOL or some dial-up accounts, there are very good reasons why you should strongly consider paying for your hosting.

Many Web hosts have a "terms of service agreement" that forbids adult content. Different hosts will interpret that in different ways, but it can mean that your site will be deleted even if you don't have photos on it. These hosts will delete your site with no warning and, in some cases, will also delete your account – including your e-mail address. So how should you go about setting up a website? I would advise you to get a domain name and pay for hosting that allows adult content.

A domain name is a permanent Web address where people can find your page. As long as you pay your domain bills, you can move the domain name from place to place and your audience will still be able to find you, even if you have to change Web hosts for some reason. Go to *http://www.networksolutions.com* and you will find more information about domain names and how to acquire one. A note of caution: when you register a domain name, anyone in the world can look up your name and mailing address. You will probably want to register your domain under a business name with a post office box address to help prevent stalkers from being able to show up at your door.

One way to find a web host that allows adult content is to find websites with adult content, go to Network Solutions to look up the domain's host and then go to the host's web page to read their terms of service agreement to see if they allow adult content. This last step is important because some web hosts are not aware that they are hosting adult sites even though they forbid it.

So why shouldn't you do the same? Because putting an adult website on a host that doesn't allow it is like playing Russian Roulette. If someone wants to hurt you for any reason, they might report you to your host who may then delete your site and your account. While you should have your site stored on disks in case of disasters, you probably don't want to have to go through the hassle of moving your site if you don't have to. It's safer to just find a host who does not restrict legal adult content in the first place.

You've got a domain name and a place to put your site – now all you need is a site! Read some HTML tutorials on the web, buy a copy of Macromedia's Dreamweaver HTML editor, get one of the HTML-for-beginners books, or pay someone else to make a site for you. Don't forget to look at sites of other sex workers offering similar services, but don't copy someone else's site. You may think that no one will notice if you copy a site but I can guarantee that it will be noticed and in the long run you'll just come out looking bad. The online sex work community is smaller than you might think at first glance.

I can tell you that making your own website is easier than you probably think it is, but there just isn't enough space in this book to go into the details. The information is easy to find. Have fun!

Advertising your web page

The biggest thing you want to avoid in advertising your website is "spam." There are many definitions for spam, but the simplest one for our purposes is "unsolicited advertisements." You may think that the Internet is like the cyber-equivalent of the Wild West where anything goes, but the truth is that nearly every message you send to the Internet, whether e-mail, a USENET post or a web board posting, is marked and traceable. If you are caught advertising where you aren't supposed to, you can quickly lose you hosting and your e-mail address. Almost everybody is tough on spam these days!

So where can you advertise your site? The safest places to mention your site are adult newspapers, calling cards, word of mouth, e-mail signature files, search engines, adult entertainment directories, sex work-oriented message boards and some USENET groups. We've already covered newspapers and calling cards. Word of mouth is easy – just mention your site wherever it seems appropriate and hope that others mention it too. What about the next item – what is a signature file?

Signature files

A signature file is a message that automatically appears at the end of every piece of e-mail that you write. Your sig file will advertise your site for you every time you write an e-mail, without resorting to spam. Most e-mail software has an option for making a sig file. Look at your software (or webmail site) and read the help files or other instructions until you find out how to make a signature file. Once you've got it figured out, put the name of your site, the URL and a little information about your site. Some people even put a favorite quote in their sig file, but try to keep your signature small. It's considered bad "netiquette" to have a sig file longer than four lines. It's always a good idea to follow netiquette practices because you're online to make friends and find clients, not to annoy people!

Here's one of my signature files as an example:

Magdalene Meretrix – Sex Worker and Author

http://www.magdalenemeretrix.com

"The prostitute is the only honest woman left in America."

Ti-Grace Atkinson

Search Engines

Getting listed in search engines is simple. Getting a useful search engine placement can be nearly impossible. There are professionals who do nothing but place sites in search engines. If you want good search engine placement, consult a professional

or pick up a book about search engine placement and be prepared to spend a lot of time working on placing your site. While search engine placement may help your business, your time is probably better spent placing your site in major adult entertainment directories and posting on sex work-oriented sites and USENET groups.

Adult Entertainment Directories and Message Boards

There are several directories and message boards online where sex workers can promote their services and advertise their webpages. Some websites are narrow in scope, addressing only fetish work or brothel work for example, while others try to cover as much of the total sex market as possible. Pay attention to the rules of the websites you visit and don't try to advertise your services on inappropriate sites. It isn't likely to get you more business and you definitely won't make any friends that way, either!

Some directories are free and others will charge you money to advertise with them. The final decision is up to you, but I don't advise paying to advertise with an adult entertainment directory. The big directories that get plenty of visitors are all free, so there's not much incentive to pay for the same service. I've provided some links below to get you started, but they are by no means exhaustive. You will find additional directories by using your favorite search engine. Also make sure to check out the links on the web pages of similar sex workers. They may have a link to a directory, webring or other resource that is particularly valuable to you.

USENET

There was a time when USENET was arguably the main recreational feature of the Internet. USENET has lost some of its glamor now that it's compared to fancy websites, message boards, e-lists and more, but it still has its loyal followers – enough that it's good business to learn how to read and post to USENET.

You can get an actual news browser (I know of at least one that is free) and read USENET that way, but the simplest way to get on USENET is to use the Deja News site. Either way, read all the instructions and read the USENET FAQ (frequently asked questions) and netiquette information linked below before participating.

Some newsgroups are for discussion only, while others are set aside for advertisement. Be sure you know which type you're posting to! People can get pretty upset about spam in their newsgroups, so it's better to join in discussions and leave the advertising in your sig file if you're in doubt. Some newsgroups you might want to investigate include:

alt.sex.prostitution	alt.sex.escorts.ads
alt.sex.wanted.escorts.ads	alt.sex.strip-clubs
alt.sex.telephone	alt.sex.brothels
alt.sex.femdom	alt.sex.services

While I'm on the subject, there are a few newsgroups that you may find beneficial for your continuing education:

soc.sexuality.general – has general sex questions and answers (you may prefer the sexwizards e-mail list, a spin-off of the old alt.sex.wizards newsgroup)

alt.sex.safe - safer sex questions and answers.

sci.med.aids – information and new developments in HIV/ AIDS (this group is fairly technical and visited mostly by medical professionals.)

As you can see, online advertising can be time-consuming and involved. Once you get the hang of it, though, you'll develop a personal schedule for visiting message boards, posting to USENET and checking out new directories, and advertising won't eat up as much of your time. It really is worth the effort, though! Sex work has always been a booming market and the Internet can be a great place to help your business really take off!

For More Info

Netiquette

http://www.albion.com/netiquette/index.html

The home page for Virginia Shea's classic book on proper online etiquette. The entire text of Shea's book is available on this site! Even if you're new to the online world, spending an evening or two examining this site will help you understand what to avoid if you want others online to welcome your presence.

Adult Chamber of Commerce

http://adultchamber.com/

An amazing collection of resources for the adult-content webmaster, including information about hosting, advertising and design. This site will overwhelm you with glee! So many questions are answered here! You'll have to register to use the site but registration is free.

Adult Video News

http://www.avn.com/

Check out their huge "webmaster's resources" section.

Internet FAQ consortium

http://www.faqs.org

A FAQ is a list of "Frequently Asked Questions" and answers to those questions. This site focuses on USENET FAQs. To learn more about USENET itself, scroll to the bottom of the index on the left and click the "usenet reference" link at the bottom.

Deja News

http://www.deja.com/usenet

One of the simplest ways for new users to access USENET.

Yahoo Resources: HTML Guides

http://howto.yahoo.com/resources/html_guides/

A collection of online tutorials – ranked from beginner to professional – to help you figure out how to make a good website.

Yahoo Resources: Escort Directories

http://dir.yahoo.com/Business_and_Economy/Shopping_and_Services/Sex/Adult_Services/Escorts/Directories/

A good place to look for directories where you can promote your website.

The Big Dog

http://www.bigdoggie.net/

Big Dog is one of the biggest adult entertainment directories on the web, specializing in escort and massage work. This is one of the most important advertising and information sites for escorts.

Georgia Powers

http://www.gppays.com

This is probably the most important site to visit if you're working in a legal Nevada brothel. Never forget that more people read a message board than post on it – in the long run you'll make more money from the people you never see on the board – so always be on your best behavior.

Yahoo Resources: Professional Dominatrices

http://dir.yahoo.com/Business_and_Economy/Shopping_and_Services/Sex/BDSM/Professional_Dominatrices/Directories/

A selection of fetish work directories where you can promote your website.

The Kinky Links Directory

http://www.thekinkylinks.com/

A fetish work directory with some variety (not just dominatrixes).

Domina Guide
http://www.dominaguide.com/
A dominatrix directory.

Open Directory: Adult Businesses
http://dmoz.org/Adult/Business/
A collection of links to various aspects of adult businesses including webmaster resources and sex services.

The World Sex Guide
http://worldsexguide.org/
Look up your region to see what services are offered. Sometimes you'll even see how much people are charging for them. The World Sex Guide is a couple of years out of date but it's a good jumping-off point in your personal research.

Busted

I've been arrested three times in my life. Each time had its own lessons to teach. There is no magic formula for avoiding arrest. It doesn't matter what sort of shoes your client is wearing or whether he showed you his penis or had sex with you. It doesn't matter what sort of car he drives or where he wants to see you. Any client could be a cop and any session of any nature could lead to arrest.

There are no magic formulas, but there are rules of thumb. Learn from my mistakes and you will be free to go out and make new mistakes, all your own. But don't think you won't make them – we all do. And if you work illegally (or legally, for that matter) for many years and manage to avoid arrest, consider yourself lucky. A well-known porn star who worked for years as a prostitute in New York massage parlors once told me that she almost wished she'd been arrested at some point. She viewed arrest as a sort of "Red Badge of Courage" for the prostitute, a coming of age, a proof of one's commitment.

While I can admire the idealism of her stance, I'm here to tell you that there is nothing glamorous or heroic about getting arrested. At best, it's a humiliating inconvenience. At worst it can destroy your life as swiftly as if you were nothing more than random calculations on scrap paper.

The first time I got arrested was a lesson in the importance of proper wording. Dolores French, author of *My Life as a Prosti-*

tute, calls prostitution a "crime of words." What does that mean? Words are what the police must use to arrest a prostitute. For example, a patrol officer may see a couple of hundred street prostitutes per year but he rarely arrests any. Why? Except for special areas like Seattle's S.O.A.P. district, a cop can't arrest a woman for looking like a prostitute. He can't even arrest her for acting like a prostitute. He might be able to get her for loitering, drugs, hitchhiking, maybe even indecent exposure if she's very bold. But the only way he can arrest her for prostitution is for her to explicitly tell him that she will have sex for money.

I was working in a strip bar the first time I got busted. I was perfectly legal at the time – I'd never been arrested before, I had a valid entertainer's license, I was of legal age and I wasn't performing any illegal acts in the dance club. In fact, I didn't even want to talk to the guy who busted me. He saw me on stage and told another dancer that he would only talk to her if she brought me over, too. The "Toughest Man in Town" contest had just finished across the street and the bar was crammed with customers. I had spotted a regular customer while I was dancing and wanted to go see him but the other dancer pleaded with me, saying that the guy she was talking to had promised a bottle of champagne if she'd bring me over.

The cop immediately started playing word games with me. He asked what he would get if he went into a private booth with me. I told him I'd treat him really nice and be really sweet to him. He insisted, what would he get? I said he'd get some special private time with me away from the crowded room where we could get to know each other better.

I never really pushed private shows at that time. I didn't like the pressure of going off to a dimly lit corner of the bar alone with a customer. It also seemed dishonest to me – the way to sell private shows was to make it sound like you would do more than you were really going to. I suspected that some girls were actu-

ally turning tricks back in the private booth, but I didn't want to do that. I felt that doing illegal work from a strip bar would just make a girl into a sitting duck. Evidently, I was right.

The cop kept increasing the pressure but I was too naïve to catch what he was doing. I was just getting pissed off that he was being so stubborn and pushy when I had a nice, personable regular waiting for me at the other end of the bar. Finally, the cop asked, "If I pay $100 to go in that private booth with you, do you think I might get a little head?" The first thing that popped into my head was the joke about the man who rescues a beached mermaid. She offers to grant a wish and he asks her for a little head so she shrinks his skull. The mental image of shrinking this annoying man's skull made me laugh and I replied, "No, but you might get something like it." In my mind, "something like it" was the clobbering upside the head I'd have loved to have given him right about then.

"That's all I needed to hear," the cop said and grabbed my wrist with one hand and the other dancer's wrist with the other. Immediately the place was swarming with cops who quite efficiently took over, hustling all the other customers out the door and separating me and the other dancer.

I was dressed only in underwear and there were several inches of snow on the ground outside. I asked the police if I could get my coat before they took me outside. They refused but demanded that I get my purse. Of course they wanted to see my I.D. card but I think they also wanted to search it for drugs. I didn't have any.

I'll spare you the details of going to jail in one's underwear. Suffice it to say that it's unpleasant. I was released the next morning and had my boyfriend bring some clothes when he came to get me. The case was thrown out of court when the judge listened to the recording of my conversation with the cop. The judge asked me what "no, but you might get something like it"

meant. When I had said it to the cop, I had intended to lick my fingers while talking about how great it was to give a blow job. When the judge asked, I told His Honor that I was going to seductively eat a banana. Everyone in the courtroom laughed. Except the arresting officer, that is. He looked especially embarrassed when the case was dismissed.

Obviously word got around because, at the next place I danced, the bouncers spent the first couple of weeks I worked there chasing me around with bananas.

The second time I got arrested wasn't quite so innocent. I actually got caught in the act that time.

I was working for a rather shady escort agency because I hadn't treated my job with the good escort agency like a real job (I'd show up late or, sometimes, not at all) and got fired. I was really hurting for money that day. Rent was due in two days and I was flat broke. I didn't even have enough money for cabfare.

As I was walking to the hotel to meet my client, a friend passed me and stopped to offer me a ride. She dropped me off at the hotel and I met my client in the lobby. He had a special key to take us to a secured floor. That's not always a bad sign because some people are really staying on secured floors, but it should have been something that alerted me anyway. I have poor eyesight but I didn't have contact lenses in those days and I took off my glasses when I was working, so I couldn't really get a good detailed look at the man or the room. That's not smart.

I had to call the agency to check in so I picked up the phone and dialed the number, forgetting to dial 9 first to get an outside line. That was a common habit of mine. I realized I'd made the mistake and hung up the phone to dial properly but the phone was ringing when I hung it up instead of making a busy signal like it normally would. That didn't register with my mind at the time. I dialed 9 and then dialed the number again. A woman answered, but she sounded different from the regular dispatcher. I mentioned it to her.

"Your voice sounds different."

"The other dispatcher had to step out for a minute. I'm watching the phones for her."

Once I'd dealt with the phones, my client started pressuring me to tell him that I would have sex with him. I had taken off all my clothes but he still had his clothes on. I had gotten careless because I hadn't been arrested yet and I needed money badly so I wasn't thinking right. I said sure, I'd have sex with him for money, and he said that was all he needed to hear. A connecting door opened and more men came in to arrest me.

Well, once I realized what was going on, I went with them quietly. There wasn't much point in fighting them. It's usually better to let your lawyer do the fighting. Just keep your mouth shut and co-operate. If I had been bright, I would have hired a lawyer. I figured I would just plead guilty since I was caught in the act. It turned out to be a really bad idea, though.

When I got to the processing station, I was really glad that my friend had dropped me off and left. The cops had done a city-wide sting and not only did I see many of my colleagues at the processing station, I saw some people that I recognized as regular drivers for some of the escort agencies in town. The drivers were all wearing handcuffs and were being treated really brutally by the police officers who were calling them pimps. Those drivers would be charged with felony offenses! When I think of all the times I had a boyfriend drive me to a session I shudder. At any time I could have rewarded a lover's devotion with a felony offense.

The judge let me off light – two years' probation and court costs – but I didn't realize I was supposed to come back to court again. The judge ordered me to take an HIV test and my lawyer was supposed to tell me when to come back for the results. I had been getting regularly tested on my own so I didn't really care about the test beyond being required to get it. I assumed the court would file my results and that would be it.

But by not returning to get the test results in person, I effectively missed a court date and a bench warrant was issued for me. I wasn't immediately arrested, either. They didn't come after me until the warrant had been out for about a year. When I lost the warrant lottery, I also lost my job (I was arrested at work) and my place to live (my co-worker lived below me and told the landlord I'd been taken to jail. The landlord issued a seven-day eviction notice. I got out of jail with three days to move.) I spent four days in jail because I was arrested on a holiday weekend. All this because I didn't hire a lawyer to tell me that I was supposed to go back to court for test results!

So what lessons have I learned from my experiences?

1. Never say anything that could be remotely interpreted as "I will have sex for money." (Unless, of course, you're in a legal Nevada brothel.)
2. Never bring anything to work with you that could make the situation worse for you if you are arrested, especially illegal drugs.
3. If you break the law, don't be surprised when it catches up with you.
4. If you've got a good working situation, treat it like a real job. Don't set yourself up to get desperate.
5. Budget your money to avoid running out right before rent is due and taking desperate measures.
6. Pay attention to your surroundings – and make sure you can see them well!
7. If something sounds wrong, chances are it is wrong.
8. Get your client to take off his clothes as soon as you can, preferably before you've taken yours off.
9. Never, ever, ever, ever, ever, ever say that you will have sex for money!
10. Don't resist arrest. Your lawyer is the person who should be fighting for your freedom. Get a lawyer. Get a good

lawyer. The system is like a hungry tiger – feed it. Even better, get friendly with a lawyer before you need one.

11. Know the difference between a misdemeanor and a felony offense. Driving someone to meet someone for prostitution is a felony. Setting a colleague up with one of your clients is a felony. Running an illegal escort agency is a felony. In some places, getting arrested for misdemeanor prostitution too many times is a felony.

12. Be religious about showing up for every scheduled legal event. Don't beat a prostitution rap just to end up in jail for missing a court date.

13. The safest way to avoid a prostitution bust is to work legally... though even that will not guarantee your freedom if you choose to be a sex worker.

Oh yeah – the fall-out of that prostitution bust was that I was no longer allowed to have an adult entertainment license in that city for ten years after the arrest. Those ten years are nearly over now, but I've long since moved on. Getting arrested ended my career in that city. It limited my options as well – I had to wait a number of years before I could work in the Nevada brothels as well.

So keep your eyes open and behave yourself. Stay out of jail, please! It's a really boring place to be, and an arrest record can put a serious crimp in your future plans.

For More Info

BDSM-D/s and the Law
http://gloria-brame.com/domidea/rumpoule.htm
While this page is mainly about the legal implications of SM play, the author, a professional lawyer, does briefly discuss the legality of professional domination.

WashLaw Web

http://lawlib.wuacc.edu/washlaw/uslaw/statelaw.html

This Washburn University School of Law page maintains links to online statutes for the United States. It can be an invaluable resource for researching the specific laws in your area.

Sex Laws

http://www.geocities.com/CapitolHill/2269/

A collection of links to information around the web about sex laws in different areas.

SEX WORKER BURNOUT SYNDROME

N o matter what your job, everyone is susceptible to burnout from time to time. Burnout is a special issue for sex workers, though, because of the way our work is viewed by outsiders. A doctor or police officer who is experiencing burnout has many places to turn for support and assistance, but a sex worker who is experiencing burnout too often hears: "Quit. That kind of work isn't good for anyone. No wonder you're feeling burned out – it's killing your soul."

Annie Sprinkle wrote about dealing with sex worker burnout syndrome in her book "XXXOOO: Volume One." I've had periods of burnout and I've talked to several colleagues who've experienced it as well. I've collected some tips – what's worked for me and what's worked for others – on how to deal with sex work burnout or, hopefully, avoid it altogether.

Acknowledge Your Burnout

All the coping techniques in the world won't help you if you aren't willing to admit that you're close to reaching the end of your rope. Because so many members of society, often members of our own families, have a dim view of sex work, we often feel pressure to maintain a super-happy, super-positive exterior in reference to our work. Oftentimes any sign of weariness or weak-

ness on the part of a sex worker leaves an opening for others to jump in and tell us how bad our work is. For those of us who have chosen a career in sex work, this kind of attack on our work isn't helpful and often just adds to the already overwhelming burden of burnout.

Keep the faith, keep your public face if necessary, but don't try to hide your exhaustion from yourself. Being able to admit your exasperation and burnout to yourself is the most important step in recovering from sex worker burnout. How can you heal when you won't admit you're hurt?

Separate Your Work and Private Lives

As much as you possibly can, keep work and home separate. This can be difficult, though possible, if you see clients in your own home or live in a brothel. The simplest step in setting a boundary line between work time and private time is using a different name for work. Almost every sex worker has a "work name." I've met a couple of workers who use their real name, but that's very rare. Most people think that a work name is to keep clients from stalking you, but a persistent stalker will figure out who you are and where you live despite your pseudonym. The real reason for a working name is to help keep work at work and home at home.

Dress differently at home. Clients are more likely to recognize you and possibly bother you on your time off if they see you at the public pool wearing the same bikini you wore on stage the night before. Wearing your work clothes all the time will keep you "on stage" all the time. Having two wardrobes costs twice as much, but you'll feel differently about yourself and others will treat you differently when you aren't wearing your work clothes all the time. Try to separate not only the style of clothing but the colors as well. If you wear black, white and red at work, consider

wearing blue and purple in your off time. If you wear black eyeliner at work, consider wearing brown eyeliner at home, or even no make-up if you feel comfortable that way.

Finally, decorate your living space in a way that separates it from your working space. If your work area is burgundy and gold, you might decorate with eggshell and sea green. This can be difficult if you work at home or live in a brothel, but there are ways to keep a separation between work time and free time even there. One quick and easy way to make a difference is to have separate quilts or bedspreads for work time and self time. A few pieces of fabric can make a big difference in how a room looks and feels. Other ways to make a room different include burning a certain incense for work or for private time to change the smell of a room, changing the lighting of a room with candles or lamps, changing the mood of a room with different kind of music.

When considering how to claim your space, stand in the room where you work and live and consider it with all five senses. A small change can make a big difference and several small changes can transform a room. It takes a little extra effort to change a room but it can make a dramatic difference in how you feel about both living and working in that area.

Simplify Your Life

At the same time that you might want to keep aspects of your life separate, you also want to try to keep your life simple. This balancing act is not as difficult as it might seem. One way to simplify your life is to try to avoid keeping too many secrets from people close to you. A double life is hard enough to maintain around strangers, and nearly impossible around friends and family!

For example, someone who works as an escort and is in a lesbian relationship might end up hiding their lesbianism when at

work, the nature of their work when socializing in the lesbian community, and both lesbianism and sex work when visiting their parents. Something has to give somewhere! In a situation like that, it's time to consider coming out to your parents, moving to a different city, coming out to the lesbian community about your sex work – anything that will simplify matters.

The more complications you add to your life and the more secrets you have to keep, the harder it's going to be to live your life from day to day without getting too stressed out. What's the point in living your life like James Bond?

Another way to simplify your life is to try to cut back on your errands if you can afford it. Buy your groceries in bulk so you don't have to go out shopping as much (unless you really like the opportunity to get out of the house, that is) or have your groceries delivered to you. Drop your laundry off at a laundromat that will wash and dry your clothes for you.

Take Care of Your Body

Taking care of your body is important for a sex worker anyway because appearance is such an important aspect of success in the industry. But being nice to your body will also help lower your stress level. The basic level of self-care is eating healthy foods and getting enough exercise and sleep. Junk food, smoking and excessive alcohol will age your face and body at an alarming rate. Ask yourself if you want to learn to live in a more healthy manner now and keep your youthful appearance as long as possible, or if you want to continue to indulge yourself and have fun yet look 50 when you hit 35.

In addition to maintaining basic health, there are some healthy indulgences that can help reduce stress levels for sex workers. Many sex workers say that regular, weekly massages are a lifesaver when it comes to conquering stress and overload. Massage

is not just relaxing – for people who work with their bodies, massage can be very therapeutic. If you're short on cash but live near a massage school, you might be able to get cut-rate massages from students who need to fill their quotas before graduating. Sex workers are members of a service industry designed to pamper people. If you don't learn to allow yourself a little pampering as well, it's easy to grow dull and jaded. Another healthy indulgence that can be very relaxing is going to a day spa. Day spas offer massage, facials, body wraps, mud packs and many other relaxing, therapeutic services. The drawback to day spas is their cost.

Joining a gym is a good idea. It gives you a place to work out regularly, and many gyms have steam rooms, saunas and whirlpools which are great for getting a sense of being "away from it all." For those who intend to work out but often procrastinate, joining a gym where you have to pay for a year or two in advance can be a strong initiative to actually use the facilities rather than letting that money go to waste.

Finally, lessons in Aikido, Tae Kwon Do or some other form of self-defense serve the dual purpose of keeping you in shape and teaching you how to protect yourself in dangerous situations. Many people say that martial arts training has given them more confidence as well as grace and stamina. Alternately, you might want to consider a non-martial spiritual body technique such as yoga or tai chi. These practices awaken a meditative state of mind that can be quite calming. Many people say that the effects of these practices follow them throughout the day.

Get Away From It All

Sometimes the best way to get your head out of a rut is to put your body someplace different. Going camping or hiking in natural surroundings is a big change from most sex work venues –

offices, hotel rooms, tiny brothel rooms, dark smoky bars. Getting out into the fresh air and wide open spaces can be especially rejuvenating after being cramped into stuffy work environments. Sex work often takes place in dimly lit places and sex workers often work nights and sleep days, so getting some sunshine definitely makes a difference. Studies have shown that being deprived of full-spectrum light can lead to depression. So if you can't get out in the sunshine, try spending some time with a full-spectrum light bulb, a light box or even candle-gazing.

If you can't get away to the countryside, you might try visiting a nicer neighborhood than where you normally live. If you live in a noisy or ugly neighborhood, spending the day in the park, the library, a university campus or other inexpensive place to visit can be a nice break from things. The zoo, if your town has one, can be a wholesome place to spend the day that doesn't cost too much. No matter where you live, there's usually someplace you can go to find some peace and beauty for the day.

If you can't go anywhere, take a mini-vacation by going to see a distracting movie or reading a pleasant book. No matter how you get away from it all, though, be sure to schedule regular vacations, both large and small. Many sex workers advise taking one day per week off for yourself as well as taking longer vacations from time to time. Setting aside one day that's solely devoted to you is not a luxury – it is a necessity. There should be one day in your week when you don't answer work-related e-mail, you don't answer the phone and you refuse to book clients. Without regular time for yourself, burnout is guaranteed.

Choose Your Friends Carefully

Life can be hard enough as it is; there's little point in maintaining friendships that make things more difficult for you. Select your friends carefully with an eye for tolerance and acceptance. I

spent several years hiding my sex work from my circle of friends, only to be rejected when it was discovered. Save yourself the stress and grief if you can. Find friends with whom you can be frank about your work.

Develop a network of understanding colleagues if you can. Sex work, especially illegal sex work, can have a tendency to isolate workers. Fight that tendency if you can and seek out friendships with the only people who know from firsthand experience what it's like to live as a sex worker.

If you're interested in feminism, be sure to seek out sex-positive feminists. Many sex workers are feminists and many feminists support sex work as legitimate work worthy of respect. Many other feminists find sex work repellent and will do everything in their power to persuade you to quit working if they find out. If you are fortunate enough to live in an area with prominent sex work-positive feminists, seek them out. They can be a great source of strength and inspiration during times of burnout.

Develop Other Interests

Always working and never taking time to do anything entertaining or frivolous can lead anyone to job burnout, sex worker or not. Try something you've never done before. Cultivate a new hobby. Whether it's building model ships, cross stitch, solving puzzles, breeding mice, writing, singing – it doesn't matter what you do, just find something that strikes your fancy and give it a try. Take lessons. Experiment. Many sex workers have abundant free time, while others have barely a scrap of free time here and there. But creative thinking will suggest something that you can squeeze into your life to add a bit of sparkle or diversionary interest.

Express Your Emotions

Keeping your emotions bottled up inside you and trying to ignore them will not make them go away. On the other hand, letting your emotions out can be cathartic and purgative. Vent your emotions in safe and appropriate ways. Allowing yourself the luxury to cry at a book, movie or memory will help keep you from bursting into tears while with a client. Taking out your aggressions on a punching bag or screaming at the top of your lungs on a roller coaster will help keep you from shouting angrily at a client over a relatively minor transgression. Owning your emotions and feeling safe to express them in constructive ways will help keep you from depression, alcoholism and burnout.

Taking up some form of art can be an excellent way to channel strong emotions. Painting, drawing, sculpting, writing, composing, photography and the like can be great outlets for feelings too strong to identify and discuss in any other way. Keeping a journal or writing letters to yourself can help you process your experiences and emotions as well as providing a concrete record of your journey towards yourself.

You might also consider looking for a good therapist you can trust. Therapy isn't just for the mentally ill – anyone willing to thoughtfully examine their life can benefit from the support and guidance of a high-quality counselor. It might take several tries to find a therapist who is comfortable with sexual issues and respects your choice of career, but when you find such a therapist it is worth the search. A good therapist can help you grow and explore life's options.

Learn Relaxation Techniques

Part of avoiding stress overload and burnout is doing relaxing things. If you can learn relaxation techniques, you will be able to

find calm serenity no matter where you are or what you are doing. Learning relaxation techniques enables you to carry a sphere of peace and tranquility around you every moment of every day.

You can go high-tech or low-tech when exploring relaxation. Some high-tech options to explore include biofeedback and brain wave machines. Biofeedback is a group of techniques designed to train you to regulate your brain activity, blood pressure, muscle tension, heart rate and other bodily functions consciously. There are therapists with expensive biofeedback machinery and there are individual pieces of equipment you can buy to use at home. Brain wave machines are contraptions that stimulate different brain waves using vibrations, flashing lights, sounds and more. There are various home models available.

Some of the low-tech options include working with breathing and meditation. It's amazing how much calmer you can feel after just breathing. Try this: Sit or lie down so that you are comfortable. Now slowly breathe in. When you feel like your chest is full of air, pull your stomach muscles in slightly and lift your shoulders slightly and fill up the rest of your lungs, all the way to the top. Hold that breath for a moment and then slowly let the breath back out. Just doing that once will make a difference. Breathing that way for ten or fifteen minutes, thinking about nothing but your breathing, will make a significant and lasting difference.

Learn relaxing ways to do things that you must do anyway. For example, if you spend a certain amount of time during the day answering your phone and making appointments, try spending some of that time sipping herbal tea, listening to relaxing music, gazing at a candle, meditating, or consciously breathing. You'll still be working because you'll be there to answer the phone when it rings, but you'll also be working on your stress level in the meantime.

Reassess Your Assumptions

A portion of the stress that is causing your burnout might be caused by feelings of guilt or shame about what you're doing for a living. Rather than running from these feelings, try getting more deeply inside them to see where they're coming from. Are those feelings the result of a religious upbringing? If so, you might want to examine your spiritual beliefs as well to see if your guilt and shame come from beliefs that you personally hold, or from beliefs that you have come to think you're supposed to hold.

Are you feeling bad because of society's views of sex work and sex workers? Try to surround yourself with people who treat you with respect and have confidence in your ability to choose the work that's right for you. If you think that you "should" feel bad about being a sex worker, think long and hard about what makes you feel that way and whether those are valid reasons for you. You might come out of it realizing that sex work truly is incompatible with your world-view, or you might come out of it realizing that you don't need others to dictate your life choices for you. Either way, give it some serious thought because this is your one-and-only life and you have to live it the best way you can.

Help Yourself by Helping Others

Sometimes the quickest way to forget about your own problems is to try to help someone else with their problems. Volunteer work is a good way to give something back to society. It can help you feel like a better person: more virtuous, more giving, more deserving, more involved. Some forms of sex work leave you with a lot of free time, and volunteer work is a great way to fill up some of that extra time and stay out of trouble. Not only that, but volunteer work looks great if you ever need to make a resume.

There are plenty of places where you can "plug in" and use your talents. Just to give you a few ideas, some of the volunteer work I've done over the years includes: playing piano for low-income elderly people at a day shelter, teaching adults to read, teaching English to foreign immigrants, reading books for the blind, maintaining a database of contact people for a gubernatorial campaign, running errands for and socializing with people with AIDS, working on a crisis hotline, serving dinner to low-income children after school, helping "special" children with their homework, and stuffing envelopes for a political campaign. If you think about your strengths and weaknesses and ask around, you can find someplace where you're needed... someplace where you can really make a difference in the world.

Analyze Your Options

Make a list of everything that you do at work. Include as many details as you can think of – things like answering phones, reading e-mail, being friendly, negotiating fees, performing fellatio. Once you're satisfied with your list, give each item a grade. You might give an A+ to "reading e-mail," for example, a C to "being friendly" and an F to "negotiating fees." Look at the grades you gave to different activities. Is there any way to get out of doing the Fs? Is it cost-efficient to spend more time doing A and B things?

Grading your work activities will give you a clearer picture of what it is that you love or hate about your work. You might see a pattern emerging that points towards a different form of sex work that you'd enjoy more. Or your grades may be pointing straight out of sex work altogether. Professional career advisors teach people to grade their work activities, by the way. This is a powerful tool – more powerful than it might seem at first thought –

and you can learn a great deal about your work preferences this way.

Speaking of professional career advisors, seek out self-help books about career choices or job burnout. While some advice doesn't apply to sex work, most of it will. Books like "What Color Is Your Parachute" or "Do What You Love, The Money Will Follow" can be very enlightening when consider what you want to do with your life. You may discover, like me, that you love sex work and it is your calling in life. Or you may discover that sex work was just a stepping stone to help you get someplace else. But you can't "follow your bliss," as Joseph Campbell puts it, if you don't pause long enough to consider just what your bliss might be.

Let Go

Be willing to make less money if that's what it takes to keep your stress levels down. Make a realistic budget to see how much money you need to survive and how much to thrive. Figure out where your "gravy point" lies after all your bills are paid and some money is set aside in savings. Once you know how much money you can honestly live on, consider cutting back your hours, switching to a form of sex work that involves less physical contact, or even quitting the business cold turkey if that's what you need to do in order to preserve your sanity.

Sometimes burnout can be cured by taking a vacation from sex, but sometimes the only cure is to let go altogether and find a different line of work. There is no shame in not being able to handle the life of a sex worker. Not everyone is cut out for sex work and it may be that you're one of the people who just shouldn't be in the profession. If you feel that you need to quit, go back to the last step and analyze your options. Can you quit right away or do you need to get training for something else? If financial

pressures are preventing your from just quitting, focusing on creating a second source of income can help burnout tremendously by giving you a renewed sense of purpose and a light at the end of the tunnel to look forward to – the day that you can finally say "I quit" and start a new life.

Don't let burnout get the best of you. There are so many ways to combat it and so many other options for your life than spending it feeling miserable and stuck. As far as anyone can tell, this is the only life you'll get. Make it the best life you've ever had!

For More Info

Blackstockings
http://www.blackstockings-seattle.com/

Blackstockings is a sex worker-run organization in Seattle, Washington. The site features archived articles from the Blackstocking 'zine and a message board aimed at providing peer support for sex workers. The Blackstockings site is a great place to meet other workers from around the world.

Lost Angels
http://www.alphapro.com/chat.html

Lost Angels is a general chat/BBS page that is frequented by a large number of topless dancers. It can be a good place to meet other workers online.

Sex Workers E-group
http://www.egroups.com/group/sexworkers

Sexworkers is an e-mail group for sex workers in all fields to network information and offer personal support to one another.

Kink Aware Professionals

http://www.bannon.com/kap/

Kink Aware Professionals is a privately funded, non-profit service dedicated to providing the community with referrals to psychotherapeutic, medical, dental, complementary healing, and legal professionals who are knowledgeable about and sensitive to diverse expressions of sexuality. While Kink Aware Professionals is aimed at the leather/SM community, it is one of the most likely places to find sex worker-friendly professionals.

Job Burnout By Robert W. Bly

http://www.smartbiz.com/sbs/arts/bly64.htm

An article about recognizing job burnout and coping with it

How to Cure Sex Worker Burnout by Annie Sprinkle

http://www.heck.com/annie/gallery/swbo.html

The original sex workers 12-step program!

Doc Potter

http://www.docpotter.com/

Useful information about job burnout, mediating conflict, going from burnout to bliss, combating worry, soothing yourself and more. The site is aimed at mainstream jobs, but much of it can easily translate to our work.

A Few Tips and
Tricks of the Trade

Sometimes people ask me very important questions about the details of life as a sex worker. They're not about earth-shaking topics like AIDS or violence, but they're still very useful things for sex workers to know.

These are the answers to the little questions: how can I keep having sex with clients when I'm on my period? How can I shave my pussy without breaking out? Should I get breast implants? Am I too old to be a sex worker?

These tidbits of information really don't fit anyplace else in this book so I've gathered them together here. If you have more questions that I haven't addressed, try some of the sex worker support groups listed in the chapter on Sex Worker Burn-out Syndrome. You'll often find a sympathetic ear and a wealth of great advice among your colleagues.

"What do I do about my period?"

Some workers choose to take a break from work each month when they get their period. This can be a good solution because it gives you a designated time to yourself as well as a rationalization for that time in case you're prone to feel guilty when you take time for yourself. But if you want to keep working during

your period or if you can't afford to take a week off each month, don't worry – there are ways to work around your period.

If you work in a strip bar or peep show where people see you but do not have intercourse with you, tampons should be fine. Some workers cut the string off so that it doesn't show. I usually just carefully tucked the string up inside me along with the tampon, because I didn't always have scissors available when I needed them.

For workers who do have intercourse with clients, there are a couple of menstrual solutions that my colleagues and I have used.

One method is to get some of the small natural sea sponges that are sold in the cosmetics aisle. Moisten the sponge (you might need to cut it in half first if it's very large) and insert it like a tampon. Periodically, you'll need to rinse the sponge out in cold water. Never use hot water because it will "cook" some blood cells into the sponge and that can shorten the length of time you can use the sponge safely. Be sure to rinse the sponge right before intercourse to prevent blood leakage. Don't worry about the sponge getting lost inside you – there's really no place for it to go. Wash your hands before and after every time you handle the sponge and throw the sponge away after about six hours and start over with a fresh one.

Another useful method is a feminine protection cup. There is currently one brand on the market, Instead®, and it's available at most large stores that carry feminine hygiene products. Instead is basically a disposable diaphragm. Sometimes I have problems with it leaking and other times it doesn't leak a bit. I prefer a regular diaphragm over a feminine protection cup because the diaphragm is professionally sized by a doctor to fit the size of your vagina and is less likely to leak if you use it for menstrual protection.

Never use a diaphragm or a feminine protection cup if you have an I.U.D. because the I.U.D. could be dislodged by the cup. As with a sponge, always wash your hands before and after han-

dling a diaphragm or feminine protection cup. The Instead box warns the user not to re-use an Instead but to put a fresh one in every time. I've always used them that way just because there wasn't a lot of time at the brothel to spend washing a feminine protection cup in between clients – I'd always slip away to put a fresh one in right before intercourse. Of course you'll want to wash a diaphragm off between uses because they are not disposable. Rinse the blood off with cold water and then wash the diaphragm according to the instructions your doctor gives you.

A third method involves completely eradicating your period at all. One form of birth control, the depo-provera injection, will cause your body to stop menstruating. You get the shot four times per year and from the first shot, your period stops although there may be occasional break-through bleeding. The downside to depo-provera is that some women have bad reactions to it such as headaches and depression. I took the depo-provera shot once and I was very ill (and unable to work) for many weeks. You should especially avoid the shot if you have a history of clinical depression.

Another way some women have used birth control to stop their periods is to take birth control pills but instead of taking the placebo week of pills, they go straight into another pack, keeping the hormone level constant. This sounded scary to me when I first heard it, but it turns out that the FDA is currently running clinical trials of a new birth control pill called Seasonale that will basically do the same thing with a placebo break four times per year.

The reason that women have lighter periods when they use birth control pills is because the pill suppresses ovulation. Without ovulation, the uterus doesn't build up its lining so the reproductive system has nothing to discard. We only bleed on the birth control pill because the switch from hormone to placebo in the last week of a pill pack signals the body to bleed

whether it needs to or not. When the pill was designed four decades ago, it was thought that continuing to have a monthly period would make the pill seem more natural and less frightening to women.

If Seasonale is approved, it should appear on the market around 2003. I have talked to a couple of women who have taken the situation into their own hands in the meantime by taking each pill pack for three weeks instead of four and ignoring the final week of pills. One of these women is a gynecologist and the other is a sex worker. Both have been taking their pills this way for years and have experienced no complaints.

I have read about the Seasonale trials and it appears that this form of birth control/menstruation control has some added positive benefits. Researchers claim that extended runs of hormones can reduce a woman's risk of of anemia, endometriosis and ovarian cancer. Reports aren't all positive, though. There can still be occasional break-through bleeding with extended hormones, and taking birth control pills every day will increase the body's annual hormone load by as much as 30%, exposing a woman to a higher risk of pill-related troubles such as cardiovascular embolism.

Still, with the possibility of Seasonale hitting the market, women may soon be able to minimize the amount of time they spend on their period without hiding their method from their doctor. With regular check-ups to spot small problems before they have a chance to become big problems, extended hormone use should be no more risky than birth control pills in general.

"How can I keep from getting red bumps when I shave my pubic hairs?"

Many women decide to trim their pubic hairs or completely shave their pubic mound. In some strip bars, workers are required

to shave so that no hair shows around the edges of their panties. (In other strip bars or live girl shows, workers have the opposite problem – the law forbids them to completely shave their pubic hair off.) Some women like the feel of being hairless. Some men enjoy women who shave their pubic hairs. The problem is, shaved pubes itch and shaving leaves red bumps!

The itching will go away with time. The more you shave, the less you will itch. Shaved pubes itch worst when they're growing back in, so the simplest solution for the itch is just to keep shaving regularly. At any rate, don't scratch – you're just likely to irritate the sensitive skin.

The bumps are a bit more problematic. For a long time, I didn't know what to do about them and I think that some clients might have suspected they were a venereal disease. That's bad for business! Finally a colleague let me in on her secret – diaper rash ointment.

After shaving, rub a thin layer of diaper rash ointment over the shaved areas of your pubic mound. The ointment is greasy and smells weird so you won't want to use it immediately before seeing a client. (Unless he has a Desitin® fetish, of course!) Don't glop it on. A thin layer will do fine. Rub it in to your skin a little and then let it soak in for about ten minutes. After that, you can wash it off. You'll need to use lots of soap and water to get it off – the stuff is greasy and clings to your skin. Be careful not to scrub your pubic region when you're washing it off or you'll just irritate the skin. Also, avoid clothing until you've washed the ointment off.

It smells funny and it's weird to get used to using it, but you'll notice an immediate difference the first time you try diaper rash ointment. From the first time you use it, your pubic region will be smoother and bump-free. In my opinion, it's worth the hassle.

"Am I too old/too fat/too small-breasted/too whatever?"

I've talked to so many women who've told me that they'd love to be a sex worker but they think they're too fat, too old, or not busty enough. The truth is, there is really no such thing as too much or too little of any quality if a woman really wants to be a sex worker. Sure, a woman who is 60 years old or wears a size 20 isn't going to be hired as a Penthouse centerfold, but that doesn't mean that she can't be a sex worker in some other area of the field.

I've found that you can still keep working as your body changes so long as you retain self-confidence and the willingness to be flexible. The glow that makes a woman beautiful comes from feeling beautiful, not from a jar, age, clothing store or clothing size. When I first started in sex work, I was in my late teens and wore about a size 14 – young, busty and slender. The last time I worked as a sex worker, I was 32 years old and about a size 26. And you know what? Just as many clients spent hundreds of dollars on the size 26 me as did on the size 14 me. The truth is that, no matter your size or age or build or skin and hair color there are men who will want to pay money to spend time around you.

A certain type of look can be a valuable tool, but it's not the only tool we have at our disposal. I've seen people with average looks make several times the money of people with Penthouse looks because the average looking woman had the right attitude and business sense. No matter what you look like, you should cultivate your mind and personality, because these are assets that can always increase in value no matter what gravity is doing to your physical attributes.

There are workers who are using their "liabilities" as selling points. Women in their 50s and 60s still work and even advertise their exact age. A Parisian prostitute named LuLu is still work-

ing at age 78 after nearly half a century in the business! In a recent television documentary, LuLu says she plans to keep working until she's 80. As for weight, the number of BBW (big beautiful woman) movies and magazines has been increasing over the years. Many of these publications are respectable and respectful, openly admiring larger women. Teighlor, a BBW model in the Los Angeles area, weighs about 500 pounds and has been in over two dozen different magazines and movies. Kitty Foxx, billed as the World's Sexiest Senior, is currently 58 years old. Kitty makes about 20 movies per year and works as a prostitute in one of Nevada's legal brothels.

Likewise, don't be afraid to play up your assets. Anna-Marie, the "Educated Escort" written about on SlashDot and in Salon Magazine, makes a point of letting her clients know that she is intelligent and well-educated. Mistress Angelique Serpent, a Vancouver dominatrix, puts her strong pagan spirituality in the foreground when promoting her services. Whatever makes you distinctive will also make you memorable. Whether you consider a quality to be a liability or an asset, consider using it when you promote yourself.

As for breast size, I read the results of a study in a men's magazine that claimed that 20% of heterosexual men prefer large-breasted women, 20% prefer small-breasted women, and the remaining 60% don't care what size they are, they just love breasts. No matter what size your breasts are, the odds are in your favor that 80% of your potential clients think they're just fine. That doesn't mean that a woman with the average bra size (which, by the way, is 34B) can get featured in the centerfold of Juggs Magazine, of course. But having average or small breasts definitely does not exclude you from sex work!

When it comes to body image, play up your good points, play down your bad points. Seek a market where you can succeed (and don't be afraid to switch venues if one isn't working for you but

you still feel drawn to sex work) and keep an outer appearance of confidence even if some days you have to fake it. Give yourself "pep talks" before work if necessary, and don't allow yourself to think negatively about your body. When you realize that you're having a negative body thought, immediately counter it with a more positive thought. The more you think a certain thought, the more it becomes a part of your reality. If you focus on feeling beautiful, you will look more beautiful.

A final note on dieting and plastic surgery: I'd advise against either. Calorie deprivation just puts your body into starvation mode. Radical dieting is the surest way to slow your metabolism and gain weight. Instead of dieting, eat sensibly and exercise regularly.

As for plastic surgery, you can get a tummy tuck to tighten up the evidence of childbirth, liposuction for those tough-to-lose areas, or breast implants. None of these procedures is 100% safe and they all leave scars. Of course it's your body and your choice. Depending on which area of sex work you choose, it may be nearly impossible to break into the field without surgery. Still, I hope that you will thoroughly research plastic surgery and the possible outcomes before making a drastic, permanent decision about your body.

If you decide to go for plastic surgery, shop around and ask others before you make a final decision. A skilled plastic surgeon can perform procedures that barely leave scars. For example, I've talked to dancers who had breast implants with a belly-button incision. They tell me that you have to find a doctor who is familiar with the procedure, but it's really worth it because it heals faster and leaves almost no scars.

Continuing Education Within the Field

Okay, you know how to dance or how to talk dirty or how to wield a whip or how to suck cock. You're set for life, right? Well, that depends on whether you want to continue to work at your current skill level or whether you want to progress in your chosen profession. No matter how good you are, there's always room for improvement.

If you have a hunger for new experiences and you want to be the best, you should consider continuing education. It would be easy if you could go down to your local community college and sign up for Sex Work 201. As you already know by now, we're not dealing with a profession where things are easy. Sex workers have to make their own breaks and forge their own path.

Sexual Dialogue

The brain is the largest sex organ we possess and arousal begins in the mind. While sexy talk is crucial for a phone sex worker, other fields of sex work can benefit from the ability to craft an erotic story on the spot as well. The best way to learn to talk sexy is to practice it. It may seem like talking dirty is simple, but you'll quickly find yourself falling into robotic repetition of sing-song phrases if you haven't practiced the art of erotic talk.

My first lesson in the difficulty of sustained erotic talk took place when I first worked in the live girl shows. I'd talk to a half a dozen men on a slow day, or five times as many on a busy day. After a couple of weeks on the job, I started to feel like a talking doll. Pull my string (or drop tokens in the coin slot, as it were) and I'll repeat the same tired phrases I've been programmed to repeat over and over. "Hi there, honey." "This is my tipslot. Slide something nice in it and I'll get your show started for you." "Do you like that?" "Ooh, baby!" After taking a mental step backwards to look at myself and what I sounded like, I knew I had to make some drastic changes.

The most important thing I learned about talking dirty is to stay in the present. I realize that sounds like something a zen master might say right before he hits you with a stick, but it's true. If you allow your mind to wander away from where you are and what you're doing, you'll fall into robot-talk or worse, fall silent. The best topics of conversation when it comes to sexy talk are the things you are doing right then and the body parts you are doing them with. It's more difficult for a phone sex operator who must use her imagination to create a situation. For the rest of us sex workers, we can talk about fantasies but we can also talk about what's happening right now.

Many men get extremely excited to hear a woman talk about what's happening when they're having sex. It may sound funny to you – after all, he knows damned good and well what's happening! But I've seen it happen; you're running your hand up and down the shaft of his cock and he's loving every minute of it. Then you open your mouth and say, "I love the feel of your smooth skin stretched over your hard cock. It feels so good sliding in and out of my hand like this. I love to watch the look on your face and see your whole body tighten up as you get closer and closer to coming!" and you can immediately see the difference your words have made. It's very gratifying, both to the worker who takes

pride in doing her best and to the client who ends up with a richer sexual experience.

Practice talking dirty to clients. Practice with a tape recorder and listen to how you sound. Practice in front of a mirror until you can say all those naughty things without feeling silly or blushing. Try writing erotic stories to stimulate your imagination. Try writing out lines of erotic talk or dialogue with no specific plot.

There are a few books that may help you in your quest to talk dirty:

For Beginners:

Exhibitionism for the Shy : Show Off, Dress Up and Talk Hot by Carol Queen, Down There Press, June 1995.

The Fine Art of Erotic Talk : How to Entice, Excite and Enchant Your Lover With Words by Bonnie Gabriel, Bantam Doubleday Dell, February 1996.

For the Advanced:

The Bald Headed Hermit and the Artichoke : An Erotic Thesaurus by Allan D. Peterkin, Arsenal Pulp Press Ltd., October 1999.

The Touch

Touch is a vital element of any field of sex work that involves a hands-on form of communication. Whether you're caressing your client's cheek, stroking his cock, kneading his back as he thrusts into you, or giving him a more standard massage, the elements of touch learned through massage training can serve you well in your work. If you want to improve the quality of your touch, your best options are: massage books and videos, mainstream massage classes, or erotic touch training.

Books and videos about massage are easy to come by these days. Check your local chain bookstore or, if you have one in your area, new age shop. You may even find some good titles in

your public library. A couple of books that I have found helpful include:

The Complete Illustrated Guide to Massage : A Step-By-Step Approach to the Healing Art of Touch
By Stewart Mitchell, Element Press, December 1997.

Erotic Massage : The Tantric Touch of Love
by Kenneth Ray Stubbs, J P Tarcher Press, February 1999.

Mainstream massage classes will teach you a great deal about the structure of the human body and how to touch it in ways that feel good, but mainstream massage has its limitations when it comes to sex work. One big limitation is that mainstream massage generally looks down on sex work. If you decide to take mainstream massage classes, you should strive to keep your sex work secret from your fellow students and your teachers. I've talked to several sex workers from different fields of sex work and different parts of the country who have been kicked out of massage school because the school found out about their sex work.

Should you decide to seek mainstream massage training as a form of higher education within sex work, I'd recommend pursuing the Esalen techniques, also known as Swedish massage (there are slight differences between Swedish and Esalen, but they are very similar). These techniques are the easiest to translate into a sexual situation. Should you seek mainstream massage training as a possible second career after sex work, however, you'll want to learn a variety of techniques, as Swedish tends to be relatively common. Combining Swedish techniques with more exotic techniques will make it easier for you to find placement in the increasingly competitive field of massage therapy.

Erotic touch training is more difficult to find. There are a few schools and workshops, mostly in California, that teach erotic touch. Some of them do not include sexual instruction while others do. One school worth looking into is Body Electric. The main

focus of the school is on gay men but the courses are varied and women are not excluded but welcomed. And what's even more exciting — the school is sex worker-friendly!

Body Electric
6527A Telegraph Avenue, Oakland, CA 94609-1113
Phone: 510.653.1594 Fax: 510.653.4991
http://www.bodyelectric.org/

If you're interested in learning more about sexual energies and the spirituality of sexuality, you might consider attending one of Susun Weed's sexuality workshops. Susun Weed is an herbalist living, writing and teaching in the mountains of New York. Although the focus of her curriculum is herbology, Susun encourages women to be "witches, bitches, dykes and sluts." Susun features regular sexuality workshops and periodically the porn star and pleasure activist Annie Sprinkle shows up to teach some classes. If you want to learn more about Western Tantra, breathing techniques and the energies underlying sexual expression, this is a great place to go!

For more information or a schedule of upcoming events:

Susun Weed
P.O. Box 64
Woodstock, NY 12498
914-246-8081

Sexual Skills

If you want to be a caring, empathetic, therapeutic sex provider, you may be interested in becoming a sexual surrogate or going through sex surrogacy training. Sex surrogacy is a young field of therapy that enjoys some legitimacy among more open-minded psychologists but is still struggling for overall acceptance. To the best of my knowledge, no sex surrogate has been arrested

for practicing under the referral of a licensed psychologist or doctor in the 30 or so years that the profession has existed. While sex surrogacy is technically prostitution, the law appears to allow surrogacy to exist so long as it is therapeutically prescribed.

A sex surrogate isn't solely a pleasure provider like a more standard sex worker, but rather a trained therapist whose goal is to assist his or her clients in overcoming sexual dysfunctions of various physical and emotional natures. Most surrogates work in California, Florida, New York or Pennsylvania, although there are some surrogates scattered throughout the rest of the country, and some surrogates travel to meet clients.

If you are interested in surrogate training, consult the International Professional Surrogates Association for more information:

IPSA
P.O. Box 4282
Torrance, CA 90510-4282
IPSA1@aol.com
http://members.aol.com/ipsa1/home.html

The IPSA site also has an excellent collection of links if you want to investigate the idea of surrogacy further before you contact IPSA about training.

Additionally, if you live in or near a major city, you can often find out about local workshops and classes through the finer adult shops in the area. Some shops to keep your eye on include:

Good Vibrations in the Bay Area
1210 Valencia Street (@ 23rd Street)
San Francisco, CA 94110
(415) 974-8980
and
504 San Pablo Avenue (@ Dwight)
Berkeley, CA 94702
(510) 841-8987
http://www.goodvibes.com/

Grand Opening! Sexuality Boutique
318 Harvard Street, Suite 32
Brookline, MA 02446 USA
phone: 617-731-2626
office@grandopening.com
http://www.grandopening.com/

Toys in Babeland
707 E Pike St
Seattle, WA 98122
(206) 328-2914
and
4 Rivington St
New York, NY 10002
(212) 375-1701
http://www.babeland.com/

A Woman's Touch
600 Williamson St.
Madison, WI 53703-4509
608-250-1928 or 888-621-8880
http://www.a-womans-touch.com/

Womyns' Ware
896 Commercial Drive
Vancouver, BC V5L 3Y5
1-888-WYM-WARE (996-9273)
http://www.womynsware.com/

Dancing

When I first started working in a strip bar, I told a co-worker
that I wanted to take dance lessons some day.

"Don't waste your money on dance lessons. You don't need
them for this business," she replied.

Well, to some extent she was right. I wanted to take dance lessons just for the sake of learning to dance better, not specifically for the strip bar, though. I eventually took some lessons and was glad I did. I took a few lessons in Eastern Dance, also called Belly Dancing, and I immediately recognized the grace and poise it added to my movements.

My advice? If you want dance lessons, get dance lessons! What's the point of earning money if you can't have a little fun with it now and then? Dance lessons are especially valuable if you think you might want to enter a National Strip-Off some day. Don't assume you need dance lessons to be a stripper – in most cases, you don't. But don't deny yourself the pleasure if you think it might be fun.

Fetish Work

There are a few places to seek more in-depth training in the skills that go along with being a fetish-oriented sex worker. These days, fetish training is valuable for the "vanilla" worker as well as the fetish worker. You never know when a client might ask for something more exotic, after all, and it's a good idea to know how to avoid injuring him or yourself while helping him live out his fantasies.

The Cleo Dubois Academy of SM Arts, located in San Francisco, California, is one option for guided training in various aspects of fetish work. Cleo Dubois has nearly 20 years experience as a professional dominatrix and has been teaching the arts for many years. She offers one-on-one training and also has submissives available to practice with.

Cleo Dubois Academy of SM Arts
650-322-0124
cleo@cleodubois.com
http://www.sm-arts.com/

Getting involved with your local SM club can be a wonderful way to learn more about SM and various fetishes. If there is a group in your area, take advantage of the valuable resource they represent and join them. You'll have the chance to play with real people, many of them far more experienced than you, attend classes and workshops and socialize with others who are interested in SM and fetishes. If you're not sure if there's a local group or not, check the Yahoo listings:

http://dir.yahoo.com/Society_and_Culture/Sexuality/Activities_ and_Practices/ BDSM/Organizations/

Also, ask around at your local adult bookstores and check the local adult publications.

Safer Sex

If the safer sex section of this book didn't bore you to tears and you'd like to stay on top of the issues and learn more, the best training you'll ever find is to volunteer for a community health project or a sexuality hotline in your area. Not only will you learn more than you ever thought possible about sexually transmitted diseases, you'll be offering a valuable service to your community.

I received an amazing education by spending a year volunteering for an AIDS program. Not only did I learn about how AIDS is transmitted, tested for and treated, but I learned what a deep pleasure there is in helping other people.

I highly recommend volunteer work of some type to all sex workers. It gets you out into a different group of people from the ones you normally spend time around, it gives you a sense of giving back to the community, it hones your compassion and it teaches you valuable lessons, many of which can be applied to a second career should you choose to leave sex work at some point.

This is just a taste of what's out there. It seems like every time I turn around I see a new school or class that is perfect for

the sex worker with a desire to grow and learn. Never forget that the world is your school and class is always in session!

◆ ◆ ◆ ◆ ◆

continuing
education

Planning for the Future

While some people stay in sex work for decades, others consider it as a stepping stone to a different way of life. If you are flexible about your style of working and self-promotion, there is no reason why you should have to retire from sex work, but if you do decide to make a break, there are some things you should consider.

The most important thing to think about is what you will do. Perhaps you already have something else in mind or perhaps you don't know what you want to do, just that you want to do something. Either way, seeking more education is not a bad idea. If you know what you want to do, you can begin preparing for it while you are still working in the sex industry. If you don't know what you want to do, exploring a variety of classes at a university or community college can help you figure out where you want to go next.

Most fields of sex work offer the luxury of time and money required to learn new things. Even if you plan to stay in sex work for the rest of your career, you'd do well to take advantage of the freedom most fields of sex work give you to learn new things and expand your horizons.

If you plan on returning to the mainstream (or even if you don't), you should have some sort of tax record so you don't have to suddenly explain how you've been living on no money. If you are pursuing one of the less-than-legal areas of sex work you will

definitely want to file taxes. Al Capone wasn't thrown in prison for murder and bootlegging, he was convicted of tax evasion. Similarly, many of the high-class madams you read about in the newspapers were not arrested for running prostitution rings but for tax evasion.

Your best bet for taxes is to consult a professional. There are so many tax laws and loopholes, regulations and state-by-state differences, that there's no way I could cover everything you need to know about taxes. Find a CPA and confide as much of your situation as you feel comfortable.

Your tax advisor will want to know what your job description is so he can fill in that blank on your tax forms. There's no need to reply "prostitute." Some examples of job titles that colleagues of mine have used when filing taxes include Independent Artist, Independent Performance Artist, Personal Care Assistant and Consultant.

Whether you invest in education or not, you'll want to learn more about investing your money. A savings account is a good start, but over the long course you'll want to look into additional options such as stocks, bonds, CDs and property. Again, a professional will be able to tell you more than I could possibly cover in this book. If you're making good money, it's worth spending some of it to learn how to make more. A reputable investment advisor will not be prejudiced against you because of your line of work. Money is money, after all.

One thing you'll have to consider if you decide to leave sex work for a more mainstream job is resume gaps. In most cases you won't want to tell your potential employer that you used to work at the "Show Me Tell You Strip Bar" or "Madam Debauchery's Legal Brothel." In most cases you will be faced with an incredible amount of prejudice if you reveal your former line of work. So how do you explain those giant gaps in your work history?

Here is where being female comes to your rescue. It's far easier for a woman to explain away work gaps than a man. Of course you may have to lie, but you'll probably feel better about lying than you would about being sexually harassed on the job with little legal recourse. Some possible stories to cover up those time periods include taking care of a sick relative, prolonged engagement or live-in relationship where your partner took care of your needs, living at home with your parents while you reassessed your life's priorities, or travel and education. Come up with a story, make sure the principal characters will support your claims, and stick to your guns.

It's not impossible to leave sex work, it just takes careful planning. When you begin, consider the fact that you may want to leave sex work someday. Plan for a different life, even if you stay with sex work until you retire. It never hurts to have extra options!

162
♦ ♦ ♦ ♦ ♦
planning for
the future

APPENDIX ONE:
LEGAL BROTHELS
CONTACT INFO

Northern Houses

Elko

The Elko brothels are all bunched together in one area. They are older buildings, not trailer complexes like some of the other ranches, and are right in the heart of town.

Chardon's (Formerly Mona Lisa)
357 Douglas Street
(775) 738-9923
Chardon's was built to be a brothel so each room has its own sink with hot water.

Inez's D & D Ranch
232 S Third Street
(775) 738-9072

Mona's Ranch
103 South Third Street
(775) 738-9082

Sue's Fantasy Club Ranch
175 South Third Street
(775) 739-9962
http://suefantasyclub.cjb.net
Sue's has seven rooms for the workers with cable television in each room. There is a worker's lounge with a computer and online

access. The bar has a dance stage where workers can dance top-less for a fee.

Ely

The Big 4
High Street

Green Lantern
95 High Street
(775) 289-9958
Green Lantern has a stage for the workers to dance on.

Stardust Ranch
190 High Street
(775) 289-4569

Outside Fallon

Salt Wells Villa
On Highway 50, 12 miles southeast of Fallon,
(775) 423-3005
(702) 423-5335
Near Fallon Air Force Base, this brothel gets a lot of military clientele. Some specialty porn stars, such as Kitty Foxx ("World's Sexiest Senior") have worked here recently.

Moundhouse (outside Carson City)
Kit Kat Ranch
5-7 miles east of Carson City off Highway 50 East
(702) 246-9975
Kit Kat was just bought by new owners who say they will be putting a lot of money into remodeling the house.

Madam Kitty's Guest Ranch (a.k.a. Kitty's Cathouse)
5-7 miles east of Carson City off Highway 50 East
(702) 246-9810
(775) 246-9832
1-888-MS-KITTY (1-888-675-4889)

Most of Kitty's has been recently remodeled so the parlor and rooms are all clean and new. This brothel probably has the largest hot tub of all the Northern Nevada brothels. The parlor is large and there are about 30 rooms, many with built-in fireplaces and big-screen televisions. Sometimes the workers get online, using AOL Instant Messenger (screen name: kkathouse) or ICQ (UNI: 5565883) and you might be able to get someone to talk to you about the brothel.

Moonlight Bunny Ranch
5-7 miles east of Carson City off Highway 50 East
(702) 246-0243
(702) 246-9901
(888) BUNNYRANCH (286-6972)
http://www.spectatormag.com/ADPGES/mb.html

Moonlight is owned by the same man who owns Kitty's. The parlor at Moonlight is tiny and there are fewer girl's rooms than Kitty's (the rooms are generally smaller than Kitty's rooms, too) but there is still a full bar and fireplace in the parlor. Moonlight has a reputation for bringing porn stars in for short-term engagements. The owner tends to put his highest booking workers in the Moonlight Ranch. There are stables behind the ranch and some of the horses are available for the workers to ride when they're off shift.

Sagebrush #1 & #2
5-7 miles east of Carson City off Highway 50 East on Kit Kat Road
(775) 246-LOVE (5683) (Sagebrush #1)
(775) 588-3099 (Sagebrush #1)
(775) 246-3803 (Sagebrush #2)
(775) 246-5683 (Sagebrush #2)
(888) 852-8144

Half of the Sagebrush burned in 1999 and is in the process of being restored.

Sparks (Outside Reno)

Old Bridge Road Brothel

East of Reno on I-80, take exit 23 (Mustang Exit), turn right after one lane bridge, 4756 Peri Ranch Rd

(702) 342-0223

This was the original Mustang Ranch. Now it's off to the side of Mustang 1&2 (which are currently closed) and has a quiet atmosphere and over 20 rooms for the workers.

Wells

Donna's Ranch

Off exit 351 on Interstate 80

(702) 752-9959

Donna's is one of the 24-hour houses where workers are "on call" all hours of the day or night. Much of the business at out-of-the-way brothels come from truckers, and at Donna's Ranch the girls get on the CB radio to lure business in. The house looks like an old tavern and was built in the 1860s to cater to the men building the transcontinental railroad.

Hacienda Sugar Shack Ranch and Rooming House

619 8th street, across the way from Donna's Ranch

(775) 752-9914

http://haciendaranch.com/

The Hacienda has about eight rooms for the workers plus a hot tub room lined with mirrors. The workers use the CB here to call in business from the road.

Winnemucca

Some of the Winnemucca workers also do live video teleconferencing online through

http://www.nevadacathouse.com/

The Winnemucca brothels are all together on "The Line" just off Baud street. The houses do not have gates or buzzers – the clients just walk right in like a bar.

My Place Ranch
(775) 623-9919

Penny's Cozy Corner
(775) 623-9959
There is an attractive jacuzzi room with an Oriental motif and a loft at Penny's.

The Pussycat Saloon
The Pussycat is the largest of the Winnemucca brothels. It is open 24 hours a day.

Simone's Ranch De Paris
(775) 623-9927
Simone's opens around 5:00 in the evening and stays open until 3:00 or 4:00 in the evening, depending on business.

The Villa Joy Ranch
(775) 623-9903
The Villa Joy has only one shift for workers – it opens around 5:00 in the evening and stays open until around 3:00 or 4:00 in the morning. The Villa Joy features the Paradise Café which is an all-nude strip bar. The Villa Joy workers often dance on stage to whet men's appetites. Once a week the workers from all the brothels on "The Line" come over to Paradise Café to dance. Women I've talked to who have worked in Winnemucca say that dance night is a lot of fun for everyone.

Southern Houses

Amargosa Valley/Crystal (North of Las Vegas)

The Cherry Patch #1 (Also known as Madame Butterfly's or Mabel's Whorehouse)
North about 80 miles from Vegas on 95, left on 160 to Ranch Road (Crystal, NV)

The Cherry Patch #2

North of Las Vegas on 95 (Amargosa Valley, NV)

(702) 372-5333

(702) 372-5468

(702) 372-5469

(702) 372-5522

(702) 372-5699

(702) 372-9984

(775) 372-5251

(775) 372-5551

(775) 372-5574

(775) 372-5678

http://cherrypatchwhorehouse.com/

http://mabelswhorehouse.com/

http://madamebutterfly.com/

Madame Butterfly's is a massage parlor and bath – strictly massage, no sex (this allows them to legally advertise in Las Vegas) – and Cherry Patch #1, also known as Mabel's Whorehouse (they are the same place) or Forty Bar Estates is right behind Madame Butterfly's.

Workers must purchase their food items a la carte here as well as pay $35 per night for their room. All workers must wear stockings or pantyhose at all times. These brothels are the closest legal brothels to Las Vegas.

Since all these ranches are owned by the same person and he decides where to place his workers, it doesn't matter much which ranch you initially contact.

The Highway 95 Corridor Between Reno and Vegas (closer to Vegas)

Angel's Ladies (Formerly Fran's Star Ranch)

Highway 95 about 2.5 miles North of Beatty, NV (115 miles north of Las Vegas and 330 miles south of Reno)

1-800-270-3793 (Oregon , Nevada, California and Arkansas)

1-775-553-9986 (everywhere else)

http://angelsladiesbrothel.com/

The rooms are large for a brothel and well kept. Showers are available for travelers and plenty of parking for big rigs. The brothel is at Nye County Mile Marker 63 and broadcasts on CD channel 19. They have a gorgeous outdoor 50 x 30 ft. pool fed by a natural hot spring, a large jacuzzi that seats about six, a fantasy suite with bedroom, kitchen and living room for "playing house" and handicap accessibility. The pool is surrounded by trees and has its own poolhouse and patio. The brothel sits on 77 acres of land.

The Cottontail Ranch

About thirty miles south of Tonopah, at the intersection of Highway 95 and Highway 3 (Lida Junction)

(775) 572-3111

Shady Lady

Highway 95 about 31 miles North of Beatty, a few miles south of Scotty's Junction

(702) 321-3126

I've been told by clients that this is the most beautifully decorated brothel they've seen in Nevada. The parlor is decorated in a French Provincial style with white couches and burgundy drapes. The brothels on this stretch of highway cater mainly to truck drivers, offering showers and coffee as well as services. Unlike most brothels, however, Shady lady does not have a bar. There are two rooms for the workers and a VIP room with a new jacuzzi.

Pahrump (North of Las Vegas)

The Chicken Ranch

About 50 miles from Las Vegas, North on Highway 160 to 10511 S Homestead Road

(775) 727-5721 (toll free from Las Vegas)
(702) 382-7870
(775) 382-7870

Sheri's Ranch
About 50 miles from Las Vegas, North on Highway 160 to
10551 S Homestead Rd
(702) 727-5916

Sheri's is in an actual building instead of a conglomeration of trailers like most brothels. There's no gate and buzzer but there's still a doorbell to keep clients from just walking in. The parlor is large, with a fountain and a baby grand piano. The worker's rooms are large and well-decorated, resembling the V.I.P. rooms in many other brothels. Sheri's has a bar, V.I.P. room and jacuzzi room and is open around the clock.

Venus Bath & Massage
About 50 miles from Las Vegas, North on Highway 160 to
9880 S Homestead Rd
(702) 727-7474

APPENDIX TWO:
U.S. SEX WORKERS' RIGHTS &
SUPPORT ORGANIZATIONS

The Adult Entertainment Advocate
http://www.xxxadvocate.com/default.html
"The Officially Unofficial Political Resource for the Nation's
Adult Entertainment Industry." News and networking for adult
video and magazine actors and models.

BAY SWAN (Bay Area Sex Workers Advocacy Network) /
COP (Coalition on Prostitution)
Carol Leigh
PO Box 210256
San Francisco, CA 94121
(415) 751-1659
http://www.bayswan.org/penet.html

Blackstockings
http://www.blackstockings-seattle.com
Blackstockings is a grassroots organization run by women who
are or have worked in sex industry jobs in Seattle, Washington.
The group offers support and networking both locally and na-
tionally.

CAL-PEP (California Prostitutes Education Project)
Gloria Lockett
PO Box 23855
Oakland, CA 94623-0055
(510) 874-7850, 839-6775

C.O.Y.O.T.E. (Call Off Your Old Tired Ethics)
COYOTE Los Angeles/Southern California
1626 N. Wilcox Ave. #580
Hollywood, CA 90028 USA
(818) 892-1859, press #1.
http://www.freedomusa.org/coyotela/index.html

COYOTE San Francisco
Margo St. James
2269 Chestnut #452
San Francisco, CA 94123
(415) 435-7950
margosj@aol.com

COYOTE was founded in 1973 to work for the repeal of the prostitution laws and an end to the stigma associated with sexual work. In addition to engaging in public education regarding a wide range of issues related to prostitution, COYOTE has provided crisis counseling, support groups, and referrals to legal and other service providers to thousands of prostitutes, mostly women. COYOTE members have also testified at government hearings, served as expert witnesses in trials, helped police with investigations of crimes against prostitutes, and provided sensitivity training to government and private non-profit agencies that provide services to prostitutes.

EDA (Exotic Dancer's Alliance)
http://www.bayswan.org/EDAindex.html
Exotic Dancers Alliance is a collective group of self-identified female exotic dancers collaborating together to obtain adequate working conditions and civil rights within the sex industry.

HIRE (Hooking is Real Employment)
Dolores French
931 Monroe Dr. NE Suite 102-175
Atlanta, GA 30308
(404) 876-1212
frenchdom@aol.com

ISWFACE (pronounced 'ice face')
http://www.iswface.org/
The International Sex Worker Foundation for Art, Culture
and Education – the international clearinghouse for all the re-
search, articles, art, culture and information by and about people
in the sex industry, past and present from around the world.

NTFP (North American Task Force on Prostitution)
Priscilla Alexander
2785 Broadway #4L
New York, NY 10025-2834
(212) 866-8854
prisjalex@aol.com

PONY (Prostitutes Of New York)
Box 199 Murray Hill Station
New York, NY 10156
(212) 713-5678

IF YOU LIKED *TURNING PRO,*
YOU MIGHT ENJOY:

GENERAL SEXUALITY

Big Big Love: A Sourcebook on Sex for People of Size and Those Who Love Them
Hanne Blank $15.95

The Bride Wore Black Leather... And He Looked Fabulous!: An Etiquette Guide for the Rest of Us
Andrew Campbell $11.95

The Ethical Slut: A Guide to Infinite Sexual Possibilities
Dossie Easton & Catherine A. Liszt $15.95

A Hand in the Bush: The Fine Art of Vaginal Fisting
Deborah Addington $11.95

Health Care Without Shame: A Handbook for the Sexually Diverse & Their Caregivers
Charles Moser, Ph.D., M.D. $11.95

Look Into My Eyes: How to Use Hypnosis to Bring Out the Best in Your Sex Life
Peter Masters $16.95

The Strap-On Book
A.H. Dion, ill. Donna Barr $11.95

Supermarket Tricks: More than 125 Ways to Improvise Good Sex
Jay Wiseman $11.95

Tricks: More than 125 Ways to Make Good Sex Better
Jay Wiseman $11.95

When Someone You Love Is Kinky
Dossie Easton & Catherine A. Liszt $15.95

BDSM/KINK

The Bullwhip Book
Andrew Conway $11.95

A Charm School for Sissy Maids
Mistress Lorelei $11.95

The Compleat Spanker
Lady Green $11.95

Flogging
Joseph W. Bean $11.95

Jay Wiseman's Erotic Bondage Handbook
Jay Wiseman $15.95

Miss Abernathy's Concise Slave Training Manual
Christina Abernathy $11.95

The Mistress Manual: The Good Girl's Guide to Female Dominance
Mistress Lorelei $15.95

The Sexually Dominant Woman: A Workbook for Nervous Beginners
Lady Green $11.95

SM 101: A Realistic Introduction
Jay Wiseman $24.95

The Topping Book: Or, Getting Good At Being Bad
D. Easton & C.A. Liszt, ill. Fish $11.95

Training With Miss Abernathy: A Workbook for Erotic Slaves and Their Owners
Christina Abernathy $11.95

FICTION FROM GRASS STAIN PRESS

The 43rd Mistress: A Sensual Odyssey
Grant Antrews $11.95

Haughty Spirit
Sharon Green $11.95

Justice and Other Short Erotic Tales
Tammy Jo Eckhart $11.95

Love, Sal: letters from a boy in The City
Sal Iacopelli . $11.95

Murder At Roissy
John Warren $11.95

The Warrior Within (part 1 of the Terrilian series)
Sharon Green $11.95

The Warrior Enchained (part 2 of the Terrilian series)
Sharon Green $11.95

Please include $3 for first book and $1 for each additional book with your order to cover shipping and handling costs, plus $10 for overseas orders. VISA/MC accepted. Order from:

 greenery press

1447 Park St., Emeryville, CA 94608
toll-free 888/944-4434 http://www.greenerypress.com